The Watercolourist's Nature Journal

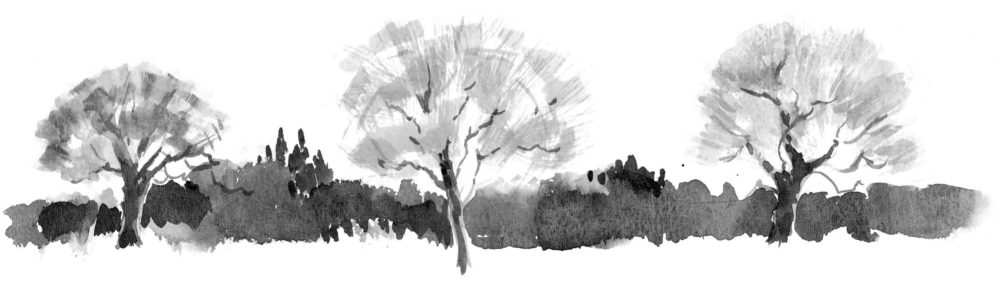

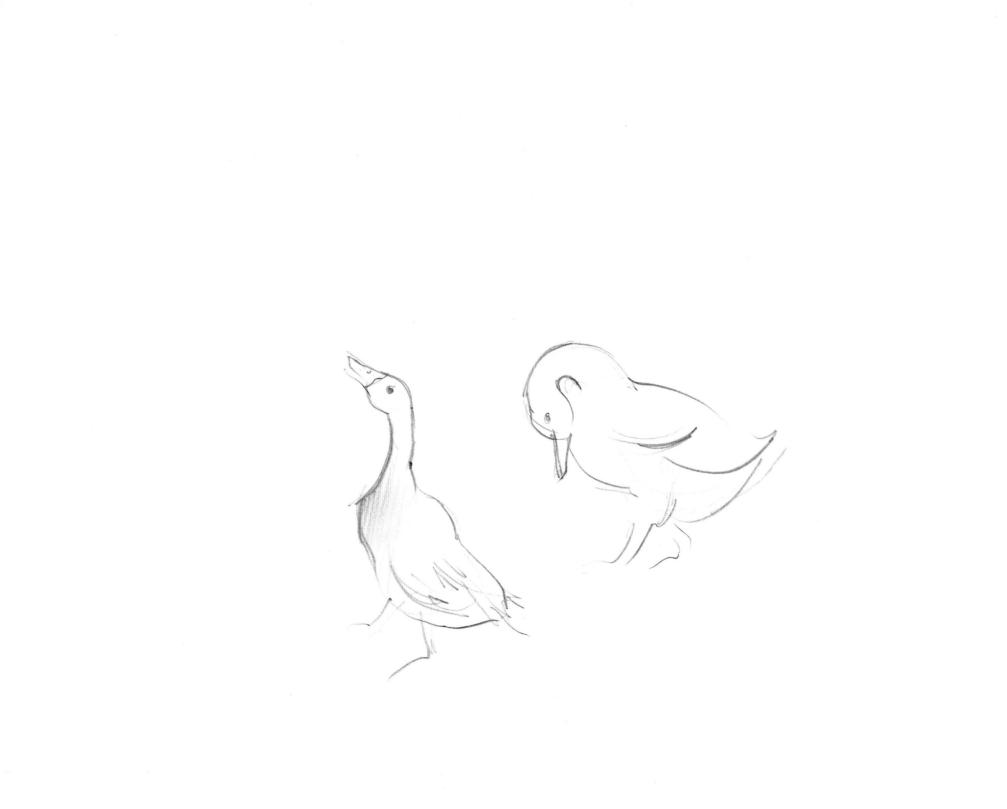

The Watercolourist's NATURE JOURNAL

David & Charles

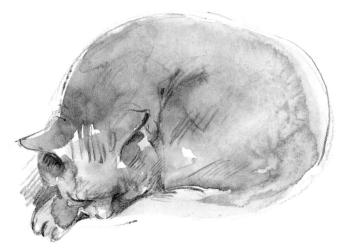

A DAVID & CHARLES BOOK

First published in the UK in 2001
Reprinted 2003

A catalogue record for this book is available from the British Library.

ISBN 0 7153 1147 6

Printed in Singapore by KHL Printing Co Pte Ltd
for David & Charles
Brunel House Newton Abbot Devon

Publishing Manager: Miranda Spicer
Commissioning Editor: Anna Watson
Art Editor: Diana Dummett
Desk Editor: Freya Dangerfield

Contents

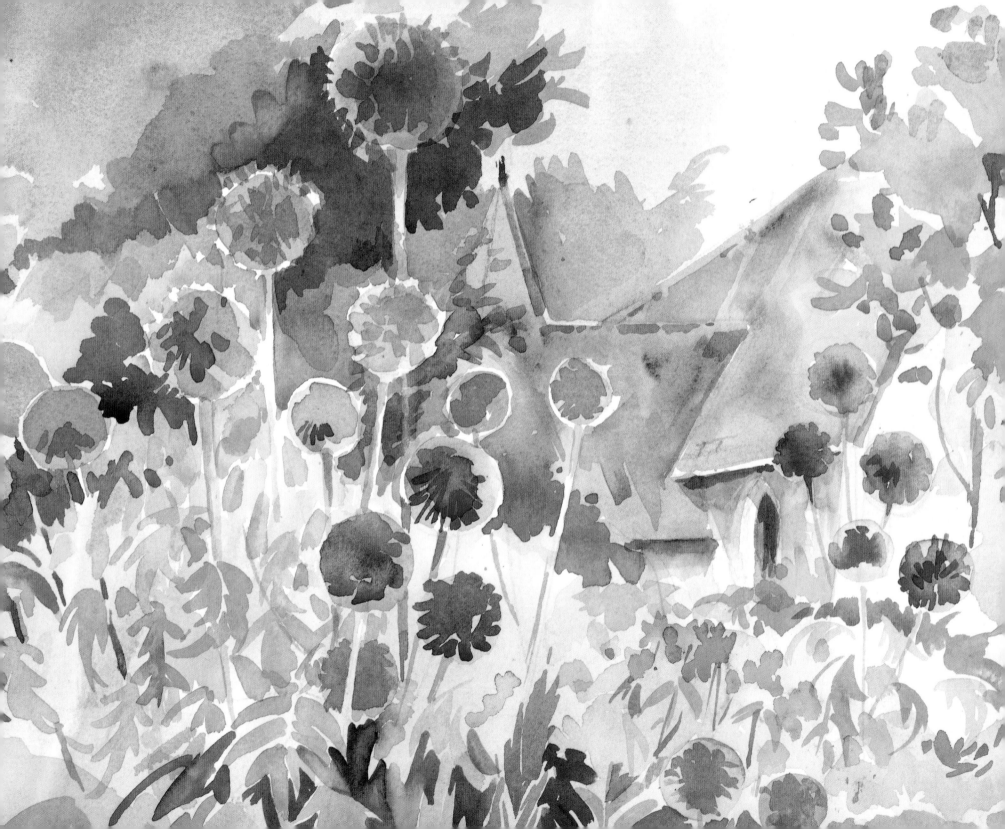

Introduction

The contemplation of nature is, for me, one of the great pleasures of life. To live close to nature is a blessing and to experience its delights revives the soul. Nature generously provides us, as artists, with an endless variety of subjects. As the seasons unfold, we are presented with a vast spectrum of colour: from the soft and fresh yellows and greens of spring right through to the brilliant reds and blues of summer, the russets and mellow yellows of autumn, and the greys and browns of winter. With each season, we can watch trees and flowers develop and flourish, witness the behaviour of animals and birds as they rear their young, and wonder at the changing skies and light. How can we fail to be inspired?

From the largest mountain landscape to the smallest backyard or even a simple vase of daffodils, there is so much to be enjoyed and learned about in nature. I have always been fascinated by woodland, fields and wild flowers and more recently by gardens. My own garden is full of subjects to paint and, close by, I find inspiration in the rivers, water meadows and hills. Some people may have a preference for a particular subject but I find that I can get interested in more or less anything, whether it is flowers, birds, still life, landscape or more figurative work. Colour, shape and form are all a challenge, whatever medium or subject you choose.

Keeping a nature journal, recording the changes in nature as the year progresses, is a fascinating way to understand the natural world. It requires discipline: you have to keep your eyes open all the time to notice the subtle changes that occur through the year and to record moods and atmosphere as well as the growing and living things. Your journal will help you to progress as an artist, as your drawing and painting skills will improve and, at the same time, your observational skills and general knowledge will increase.

Even on the dullest winter day, if you look, you will find something of interest. Wrap up warm and make sketches for winter landscapes or, at this time when little is growing or flowering, look for exotic flowers from other climates in the shops, or explore the tropical greenhouses in botanical gardens to experience a different type of vegetation. This is also a good time to set up natural objects to paint indoors, or to paint indoor pot-plants.

Your journal might take the form of a single, beautifully bound, volume in which you record the world around you as an illustrated diary, or you may choose to record the changing aspects of the seasons in a series of sketchbooks and finished paintings. However you choose to work, you will soon build up a wealth of resource material in your sketches, drawings and paintings on which you can base more detailed paintings, composed of the various elements that you have recorded. Watercolour is an ideal medium for nature studies and there are many ways in which it can be used: it can accurately and painstakingly depict aspects of nature, or with a few fresh and loose strokes, can conjure up impressions of images, leaving the onlooker to fill in the details.

I hope that as you read this book you will feel encouraged to look, draw and paint the infinite variety of subjects that nature provides. In doing so, you will become more aware of the world around you, and you will become a more informed and better artist as your painting skills develop with your enjoyment and enthusiasm.

OPPOSITE *Painted in late summer on a lovely still and sunny day, this church in Sussex provided a backdrop to the echinops and other flowers. I had considered the composition for some time and have always liked the idea of looking between plants to something else of interest. Here, the church provides a focal point which the eye is drawn towards – with other compositions you could find another interest, for example figures, atmosphere, colour or contrast can provide the viewer with a focus.*

Materials and Techniques

We can use many different ways to depict our subjects in watercolour, from line and wash to pure watercolour brushwork. In addition, there are various interesting techniques that can be learnt, from resist to washing out. There is a wealth of materials to choose from and the beginner will need some guidance, although you can always make a start with just paper and pencil before you venture into watercolour painting. I will look at brushes and watercolour paints on the following pages and begin by looking at paper and the other materials and equipment that are useful to the artist.

Paper

Paper is important, so buy the best you can afford. There are many different kinds of paper, but you will probably need to use only cartridge paper and watercolour paper. Cartridge paper has a smooth surface and is useful for drawing and line work with a pen. The heavier weight papers can take light washes of colour.

Good watercolour paper is often watermarked, and the side on which you can read the watermark is the side to use. Get to know different papers; sample sheets are often available from stockists.

You can obtain watercolour paper in sheets 762 x 559mm (30 x 22in), or in pads of various sizes. Blocks of paper are available too (these are gummed at the edges and the paper does not need stretching).

Watercolour paper is available in different weights: lightweight paper, 190gsm (90lb) is suitable for sketching and light washes; mediumweight paper, 300gsm (140lb) is suitable for most work, heavier weight paper 400–638gsm (200-300lb) is ideal and does not need stretching, but it is more expensive.

As well as different weights, there are three different surfaces: 'rough', which has a tooth or texture, is ideal for landscapes; 'NOT' (cold-pressed) paper has a finer texture and is suitable for most uses; 'hot-pressed' paper is smooth and good for line and wash.

Sketchbooks

There are many different sketchbooks available. Some contain watercolour paper, others cartridge paper of various weights. I have various sketchbooks which I put to different uses. My A4 and A5 books both contain cartridge paper which I use for pencil sketches as well as pen and ink work and light watercolour washes. My larger pad which measures 457 x 355mm (18 x 14in) is useful for outdoor watercolour sketching.

Drawing Boards

You will need a drawing board as a support for your paper. I find it helps to have several of varying sizes. Lightweight marine plywood is quite a good material to use. Hardboard is not advisable as it tends to warp when you stretch paper onto it. You can fix your paper to your board with tape or clips, or stretch it onto the board with tape.

Stretching Paper

To prevent cockling when washes are applied, particularly to lightweight or mediumweight papers, you really need to stretch your paper. To do this, you will need water, a board, paper and gummed paper tape (do not use masking tape). Damp the paper, place it on the board, and tape the edges, making sure you press the tape down firmly. Wipe off any excess water. Leave flat to dry, so the paper will dry with the tape holding it firmly. Stretched paper has a firm, taut surface which takes washes easily. When you have finished your painting, remove it from the board using a craft knife.

Additional Materials and Equipment

A sketching easel can be a useful piece of equipment. You will need to have some clips to attach your work to the drawing board, and two water pots. A small natural sponge is useful for damping paper and washing out, and kitchen paper towel has many uses.

Other useful items for drawing include the following: graphite pencils (B, 2B, 3B); watersoluble coloured pencils; felt-tip pens (waterproof and non-waterproof); a dip pen; ink (waterproof black and sepia ink); conté crayons; a plastic eraser; a craft knife for sharpening pencils (and for scratching out on your work); and a ruler (useful for measuring and judging angles).

To achieve some of the painting techniques you will need masking fluid (a rubber solution which acts as a resist); a ruling pen or the sharpened end of an old brush to apply the masking fluid; and an old toothbrush (to be used for spatter work).

A viewfinder is a useful item to include to help you to select your composition. This can be made by cutting a small rectangular window out of a piece of card in which to frame your subject.

Brushes

For successful watercolour painting, it is important to use good brushes. I use sable brushes, but there are excellent synthetic alternatives. Cheap brushes are a liability – the hairs can fall out and often they bend alarmingly. Most artists have preferences for certain types of brushes, and it is only through experience that you will be able to make your own choice.

My No. 12 sable is a useful all-purpose brush – good for washes, and also for fine lines as it has a good point. I also use a No. 7 and a No. 4 sable. For other purposes, I sometimes use a wash brush, a flat brush and a quill brush.

Flat brushes are good for painting buildings.

Wash brushes hold a lot of paint and are used to apply washes.

Quill brushes give a lovely flowing line.

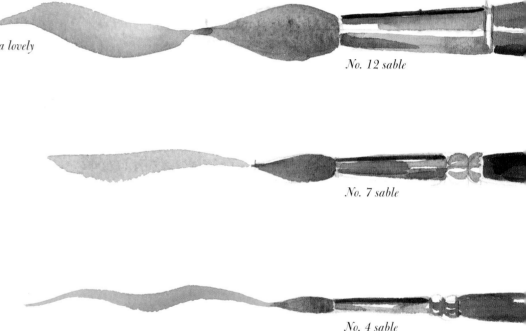

No. 12 sable

No. 7 sable

No. 4 sable

LEFT AND ABOVE *Some of the brushstrokes that you can use are illustrated on this page. Others that are useful to know include dry brushmarks which are made by dragging a brush over the surface of the paper so that the 'tooth' of the paper creates a broken stroke. A rigger brush can be useful for making fine lines to represent subjects such as small branches or twigs in landscapes. For extra-fine lines, such as stamens or fine twiggy branches, I use a dip pen.*

BELOW *A variety of brushstrokes and techniques have been used to paint these grasses. A light wash was allowed to dry before painting further washes, but primarily this subject is a vehicle for exploring different brushstrokes from broad to fine by varying the pressure on the brushes and the way they are applied to and lifted from the paper. The sharp end of a brush has also been used to scrape out marks in the wet paint. Painting foreground grasses can be a challenge, particularly if the foreground is light against a dark background.*

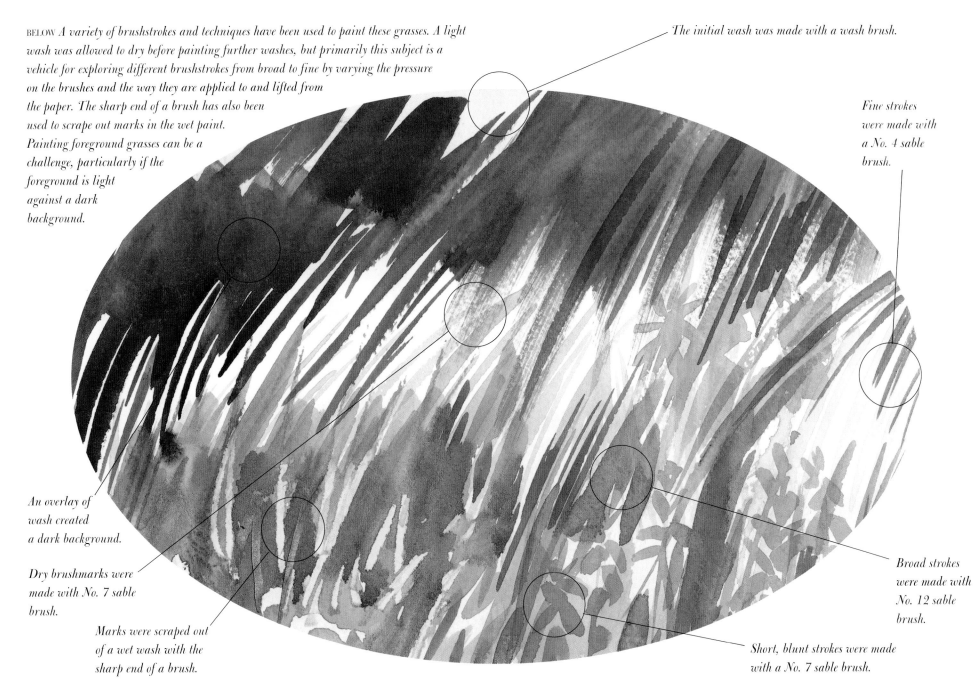

The initial wash was made with a wash brush.

Fine strokes were made with a No. 4 sable brush.

An overlay of wash created a dark background.

Dry brushmarks were made with No. 7 sable brush.

Marks were scraped out of a wet wash with the sharp end of a brush.

Broad strokes were made with No. 12 sable brush.

Short, blunt strokes were made with a No. 7 sable brush.

11

Paint and Palettes

Watercolour paint can be bought in individual tubes or pans, or in sets. I personally prefer tube paint, which I squeeze into the compartments of my palette, giving me the range I require. The illustration here shows my choice of colours, but I suggest that you start with just a few and gradually build them up to create your own personal choice. I always set my colours out in the same order so that I don't have to think where each colour is on the palette when I am painting.

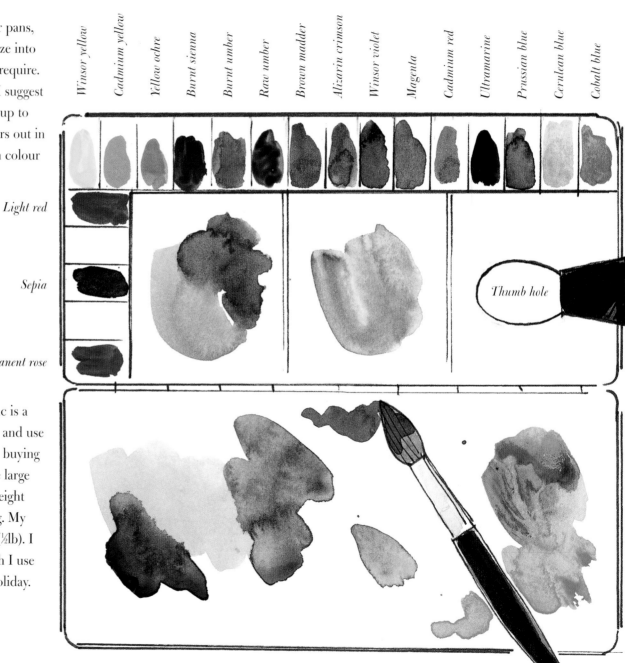

Winsor yellow
Cadmium yellow
Yellow ochre
Burnt sienna
Burnt umber
Raw umber
Brown madder
Alizarin crimson
Winsor violet
Magenta
Cadmium red
Ultramarine
Prussian blue
Cerulean blue
Cobalt blue

Light red

Sepia

Thumb hole

Permanent rose

There are many palettes to choose from. The most basic is a white plate – you can place your paint around the edge and use the centre as the mixing area. The main criterion when buying a palette is the size of the mixing area, which should be large enough to hold a wash. A palette should also be lightweight and not too large so that it will fit in your sketching bag. My palette is a metal paint box that weighs less than 250g (½lb). I also have a small box, which holds fewer colours, which I use for landscape painting on location and when I go on holiday.

Colour

Colour can be such an absorbing feature of painting that you can be attracted to a subject by its colour alone, regardless of content. Much practise is required to become familiar with the way colours behave when they are mixed.

Get to know the primary colours – red, yellow and blue (see below) – and by mixing them in pairs, obtain the secondary colours – orange, green and purple (see right). Through further mixing of these colours you can achieve greys, browns and neutral colours (see also right).

A full strength, or saturated, colour (that is, a colour that is mixed with the minimum amount of water) can be diluted with water to obtain a huge range of tints. You will discover that some colours are transparent and some more opaque (for example, aureolin is transparent, cadmium yellow is opaque). You will also find that some colours tend to separate (or granulate) on the paper, while others have a staining habit. Experience will enlighten you.

I have a few golden rules:

- Get to know the colours on your palette.
- Always keep the colours in the same order on your palette.
- Fill your palette ready for use before you start.
- Keep your palette clean.
- Ensure you have enough mixing space.
- Change your painting water frequently.

Cadmium red

Cadmium yellow

Ultramarine

Cadmium red and cadmium yellow mixing to make orange.

Winsor yellow and ultramarine mixing to make green.

Ultramarine and alizarin crimson mixing to make purple.

The three primary colours mixing to make brown/grey.

The three primary colours mixed together making neutral colours.

Complementary Colours

When a pair of primary colours is mixed, a secondary colour is made. The third primary, which is not included in the mix, can be used to provide a contrasting or complementary colour – this means that blue and orange, red and green, and yellow and purple become complementary colours. When used in a painting, they can enliven and enhance the colour values. There are many naturally occurring examples of complementary colours such as red berries and green leaves, and gardeners often exploit this type of colour interaction when designing gardens.

BELOW *These crab apples were a very pretty yellow-orange colour and I have used them here to illustrate the harmonious effect of the complementary orange and blue colours when used together in a painting. Autumn provides many good examples of oranges, from dying leaves to the many flowers which are still in bloom throughout the season.*

RIGHT *This red door caught my eye, and with the green hanging basket was a good example of a subtle use of complementaries red and green. Examples of adjacent complementary colours often occur naturally, but you may have to contrive them at other times.*

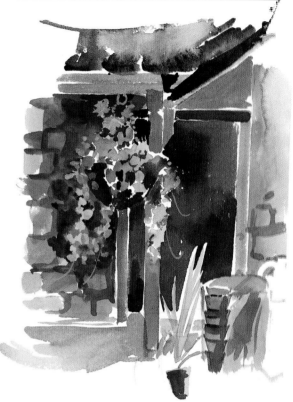

BELOW *This small painting of a bonfire is predominantly purple and yellow which are opposite colours on the colour wheel. The other colours in the painting (greys, browns and greens) are mixed from the three primary colours.*

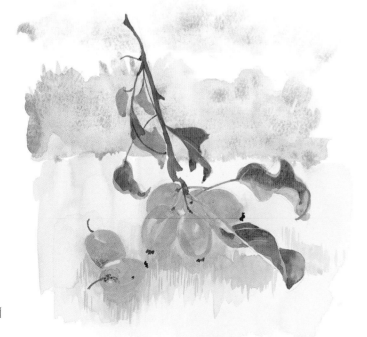

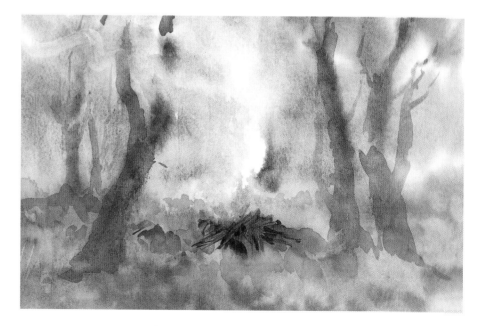

Greys and Darks

Grey is a colour worth spending time on. There are ready-made greys, which have their uses, but they are often very neutral, and it is more interesting to try mixing various combinations of warm and cool colours to produce your own. Three that I use regularly are illustrated in the sky paintings on the right. There are other mixes, of course – for example you could try using cobalt and light red. Do try to experiment for yourself and try to remember how you arrived at the particular colour by keeping a note of the mix.

If you find it difficult to achieve a really dark colour, try mixing the darkest colours in your palette. I prefer my dark colours to have a warm or cool base, rather than to use a ready-made black.

Ultramarine and alizarin crimson

Prussian blue, burnt sienna and alizarin crimson

Greens

There are many greens, but the majority of ready-made greens need the addition of an earth colour to tone them down. I mix my own greens from blue and yellow, and generally aim for a light, medium and dark tone. Although there are many subtle in-between blends, this helps me to sort out tonal values as it simplifies complex subjects.

Ultramarine and cadmium yellow

Prussian blue and cadmium yellow

Prussian blue and burnt sienna

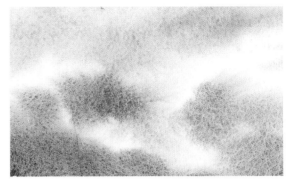

Ultramarine and burnt sienna – making a cool grey.

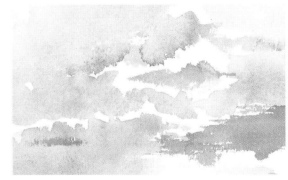

Ultramarine and brown madder – making a warm grey.

Cerulean and light red – making a neutral grey.

15

Useful Watercolour Techniques

These techniques are just a few of the many ways to achieve interesting effects in your work, and are best learnt through the experience of painting itself.

WET-INTO-WET

This is the term given to the application of wet paint on to wet paint, causing it to run and mix on the paper. Here the three primary colours have been mixed together to give a subtle colour effect.

SCRATCHING OUT

Scratching out is another method of achieving white, but in this case the painted surface of the paper is scratched with a sharp knife to reveal the paper, giving a sparkle to the water.

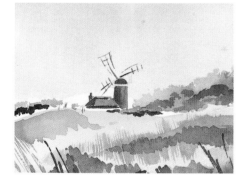

OVERLAYING

Overlaying is painting over dry paint. This can give an added richness to the colour, particularly where pure colour has been used.

DRYBRUSH

Drybrush involves skimming the brush over the paper to leave broken brushstrokes. A rough textured paper is best for this technique.

LEAVING WHITES

The surface of the paper is your white, so leave white shapes where required. Here, the side walls of the house were left untouched where they were in full sunlight. A masking fluid resist can also be used to preserve the white of the paper by painting the fluid on the paper and, when dry, applying washes. When the washes are dry, rub off the fluid with your finger to reveal the paper below.

SPATTERING

Spattering can give some interesting effects. You can use your brush to scatter paint on the paper, or use an old toothbrush and run your finger over the bristles to spatter the paint.

BELOW *This painting of thistle heads shows a variety of techniques used in watercolour painting.*

Scratching out

Fine brushwork

Wet-into-wet

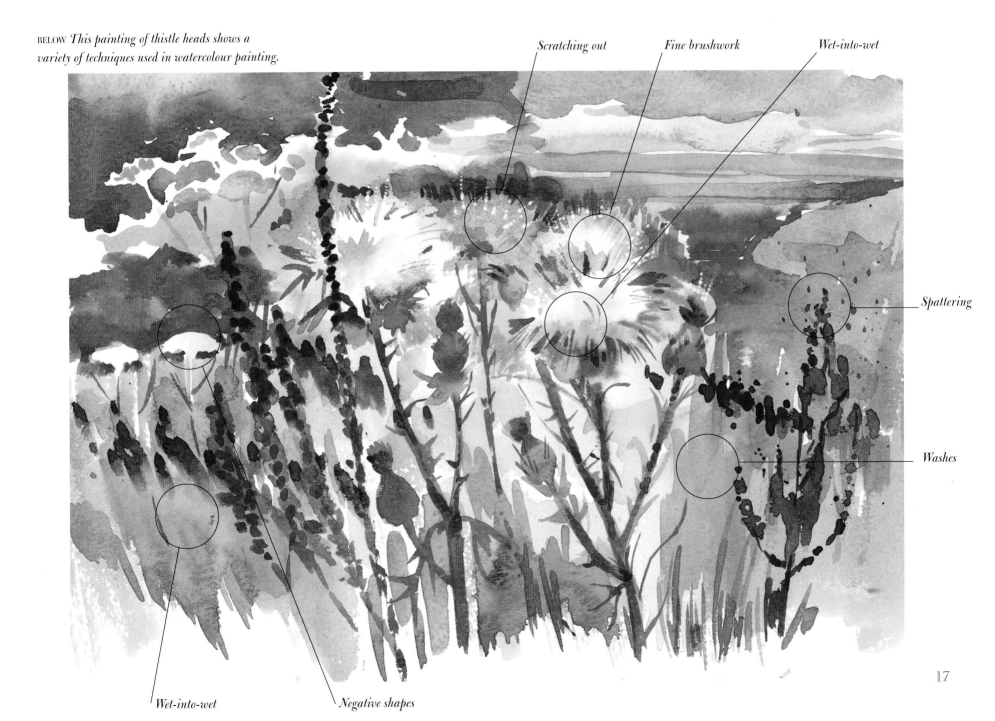

Spattering

Washes

Wet-into-wet

Negative shapes

Drawing and Painting Outside

There is quite an art to preparing to work outdoors. All too easily, you can find that you are carrying an enormous amount of equipment that you don't need. I usually take basic painting materials – plenty of paper, a board, brushes, a water pot and palette, and a pencil or two – and also a stool and a hat. An easel (even a lightweight one) can be quite heavy, but in some cases it is essential.

If you are travelling by car you can put all your painting gear in a large box. But if you are using public transport or walking why not try taking a rucksack or fishing bag? Don't forget that you could be tempted to walk further than you intended, and to arrive hot and bothered is not a good idea.

If you are going out with the express idea of sketching you can cut right down on your materials, taking just a sketchpad, a pen and pencil or some watersoluble pencils, and a water bottle.

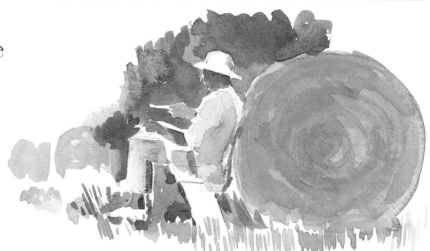

ABOVE *When you are painting outside try to make yourself as comfortable as possible, and if the day is windy, try to find some shelter. You can rest your drawing board or sketchbook on your lap, but for larger paintings you might want to consider using a lightweight sketching easel.*

BELOW *When painting outside take only the essential equipment. A lightweight stool is useful and if you want to cut down weight even further, a bin liner is useful to sit on!*

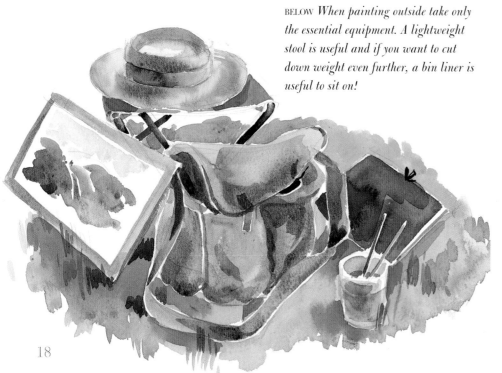

Sketching

The art of successful sketching comes from practice. Often you will have very little time and may just draw a few lines; sometimes a drawing which starts as a sketch can turn into quite a careful study. But certainly the more drawing you do, the more it will help you to 'speed up' and make sketching enjoyable.

Making sketches is a way of recording data which no machine can do. A camera can provide photographic backup references which are useful as visual aids, but sketching is such an intimate activity that it enables you to remember the situation, time and place very accurately when you look back through your sketchbooks. Skies, plants, insects, animals – the world is at your fingertips!

Sketches have many uses; some may help you to discover new techniques, others will be preliminary drawings which help with your painting. An 'idea' sketch (see page 19) will help you to put your thoughts in order and to plan a composition before starting a larger piece of work.

ABOVE **SEALS BASKING AT BLAKENEY POINT**
These little watercolour sketches were made from photographs taken from a boat and also from memory. The seals swam around the boat for some time, so I was able to observe them quite closely – they have such large eyes and engaging expressions.

BELOW **SKETCHBOOK DRAWINGS**
The reeds on the marshes provided an exciting ever-changing pattern of lines which I tried to capture here with the expressive marks of a dip pen.

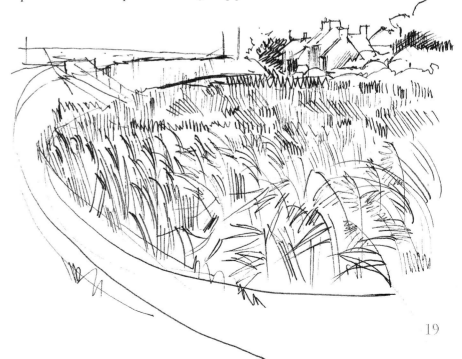

ABOVE **COLOUR IDEAS**
I made this quick watercolour sketch to capture the effect of the shifting sunlight on the marshes. The colour was amazing – the light ochre shore against a deep grey-blue sky, and streaks of green and brown marsh lit up by the light red grasses. I turned around to make this sketch while I was painting A Norfolk Village (see page 20), as the light was changing constantly.

NORFOLK VILLAGE

In every direction there was a subject to paint! I liked the quiet and subtle colours of the foreground and the sky was interesting, if ever-changing. The group of cottages was actually in shadow when I started, creating a contrast to the bright sky behind, but of course as I worked on through the morning they gradually became brighter. Often when painting, you have to make decisions and try to stick to them! I started with the sky on damp paper, followed by the light foreground washes. I used masking fluid when the foreground washes were dry, and when that was dry proceeded with other washes.

NATURE'S YEAR
IN WATERCOLOUR

SPRING
Nature's Palette

The colours of spring are light and fresh – yellows and greens are pale, pinks are soft and blues are cool. Useful spring yellows are cadmium, aureolin and gamboge, but other yellows, such as ochre and raw sienna, all play a part. Remember that some yellows, such as the cadmiums, are opaque, while aureolin and gamboge are more transparent. I always have a full palette ready at the start of painting. You may not use all the colours mentioned here, but you should have your paints ready for use and not in the tube.

There are many greens to choose from, but the main point to remember is that your green should not be watered down, but alive with colour. Most prepared greens need to be combined with an earth colour to work successfully, but you should try mixing your own using blues and yellows. It is a good idea to have a light, medium and dark green ready for use.

Many pinks can be made from tints of reds, but true pinks such as rose madder genuine and permanent rose are lovely colours which are worth including in your palette. Magenta, mauve and ultramarine are useful to experiment with to create shadow colours for different situations.

As the warmth of the sun increases throughout the season, and the countryside slowly becomes alive with colour, hedgerows will sparkle with fresh greens and banks of trees will change from drab browns and greys to ochres, soft reds and greens. The longer days encourage wild flowers to grow – celandines, buttercups and cowslips could be represented by gamboge or cadmium yellow. In the garden there are daffodils and many other bulb plants coming into flower. Added to this are the trees which blossom so profusely – many actually produce flowers before their leaves so that gardens and hedgerows appear pink and white.

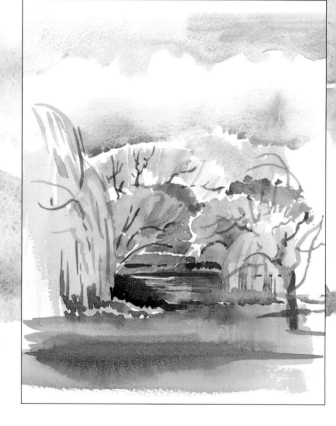

ABOVE *This little sketch shows many of the colours from the spring palette – gamboge and ultramarine for the willow, rose madder for the almond tree, cobalt for the sky, and yellow ochre for the distant trees.*

Yellow ochre

Cadmium yellow pale

Gamboge plus cerulean

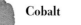

Rose madder genuine

Cobalt

Ultramarine

Ultramarine plus burnt umber

Burnt umber

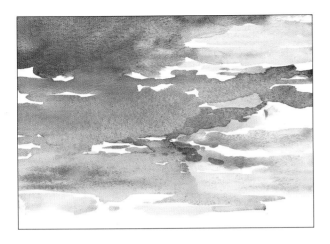

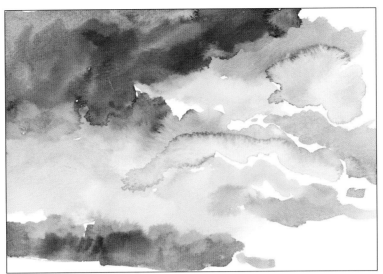

LEFT AND BELOW **SKY STUDIES**
These studies, taken from one of my sketchbooks (A5 Bockingford paper), use a variety of colour mixes. Spring skies are usually a cooler blue, such as cerulean or cobalt. Get into the habit of working directly with a brush when painting clouds, and try a variety of techniques, such as wet-into-wet and the drybrush technique (see page 16). I always advocate working with a large brush – mine is a No. 12 sable with a good point. When working in the studio you will be able to use a more considered approach to painting clouds (see page 101).

Painting Skies

Spring skies are ever-changing. Some days the sky is so beautiful that you feel compelled to get your paints out; on other days it can be very dull and grey, or even stormy. You need to be prepared for all eventualities by having a good knowledge of cloud colour and form, and the techniques to use to capture these.

If you are a beginner you should know how to make a flat wash, and, following on from that, a gradated wash (see page 117). Experiment with colour – are you able to achieve a pale yellow fading to blue without it turning to green, are you able to make warm or cool greys without resorting to using Payne's grey?

Make some sky sketches on a small scale, like the ones I have done here, to become familiar with ways to achieve different effects through the handling of the brush and a knowledge of colour mixes. Painting skies in this way is an excellent forerunner to painting landscapes.

If the weather is cold, it is possible to get a fair amount of practice from indoors by looking out of the window, but it is always more exciting to get out and have a go.

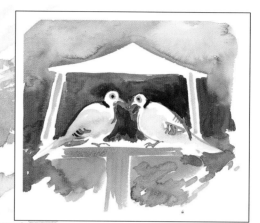

OPPOSITE **MAGNIFICENT MAGNOLIA**
Right next to my house is a magnificent magnolia, its large, pale, tulip-shaped flowers creating a marvellous display against the sky. This sketch was painted between showers and captures the colours of early spring.

LEFT AND ABOVE *In early spring, my sketchbook shows sketches of windy skies, cooing doves preparing to pair up, and the new growth on trees in the form of early blossoms and catkins.*

BELOW *I found these flowers growing near the road – they are a cultivated version of comfrey.*

Early Spring

Before the end of winter, you can see the leaves of the daffodils pushing through the soil and you can hardly believe that spring is on its way. The first flower you often see is the crocus, then the delicate white blossom of the blackthorn. When the pussy willow appears, you notice that the willows are gradually changing colour, and alder trees begin to show their catkins along with the hazel. At the start of the season, in brilliant sunshine, I noted daffodils, celandines, almond blossom and crocuses all bursting into flower.

BELOW *As it is early spring I felt I had to draw young lambs. I sketched these from a long way off so as not to frighten them.*

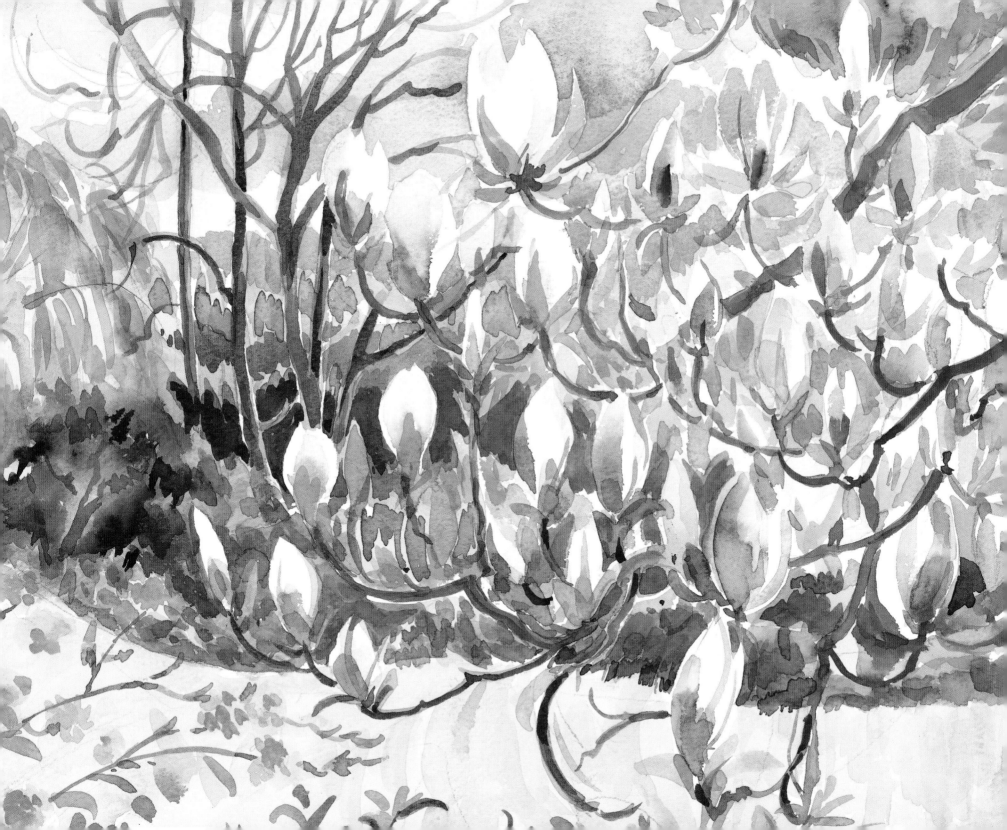

Using Your Sketchbook

BELOW AND RIGHT **HORSE AND COW**
You have to work quickly when sketching animals as they are always on the move. Sketch the essential elements and general shapes – the curve of the horse's back, the direction of the contour lines.

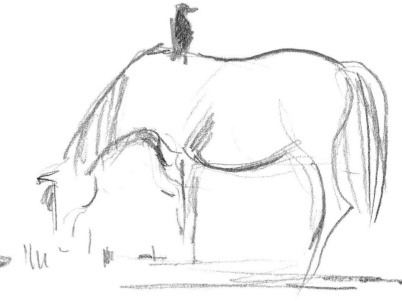

LEFT **HERON**
Herons are frequently seen around the river. They have a prehistoric look when flying and are often mobbed by crows. Although they raid ponds for fish, you can't help but admire these graceful birds. They perch on the tops of willow trees as in this sketch, and never fail to excite my admiration. I used a watersoluble graphite pencil here with a little watercolour.

As spring progresses, it becomes possible to go outdoors sketching more and more. When you go out, take plenty of paper – a large sketchbook is ideal – and make sure you have enough pencils. If you decide to sketch with a watersoluble pencil, take a soft grade, an 8B perhaps, and you can then add tone with a little water and a brush, or even your finger. For larger drawings, conté pencils are pleasant to use. If you want to use colour, a small watercolour box with a brush and water container is ideal.

The sketches on these two pages were drawn directly with pencil with some watercolour added as appropriate. When sketching animals such as these, try to capture the essence of the subject – with animals and birds this is not easy but make start, and if your subject moves, try again. Remember to always draw from the actual subject if you can. Start with the general shape and leave the detail until last. Use a line to draw the basic form and then add tone if needed – if you have time, add colour.

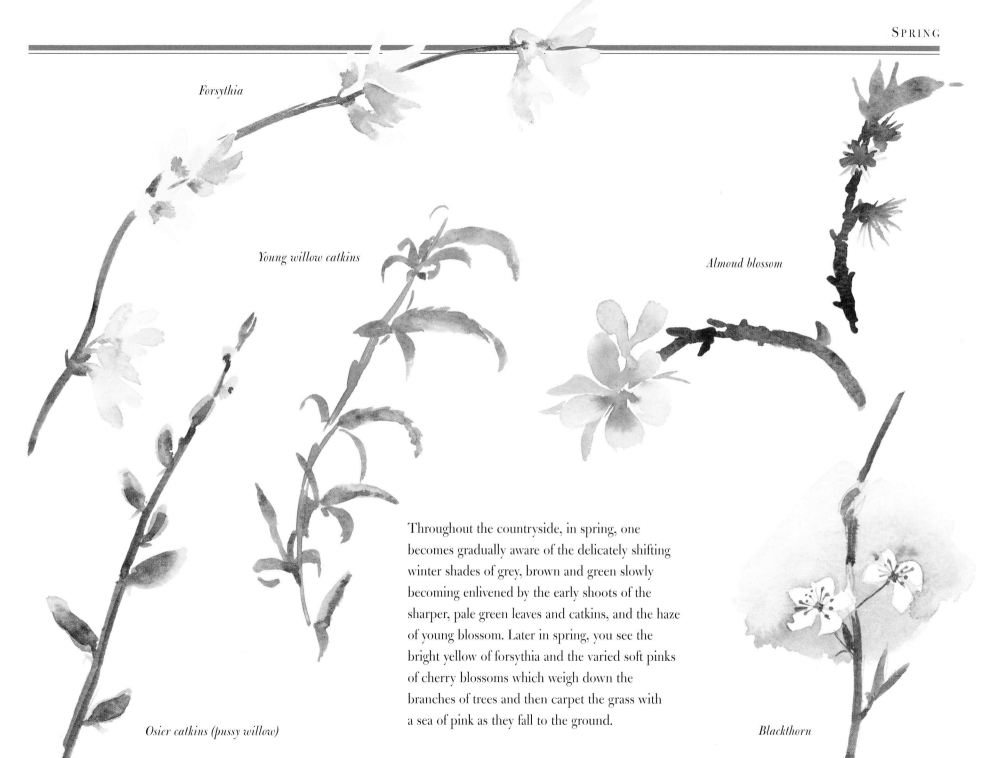

Forsythia

Young willow catkins

Almond blossom

Osier catkins (pussy willow)

Blackthorn

Throughout the countryside, in spring, one becomes gradually aware of the delicately shifting winter shades of grey, brown and green slowly becoming enlivened by the early shoots of the sharper, pale green leaves and catkins, and the haze of young blossom. Later in spring, you see the bright yellow of forsythia and the varied soft pinks of cherry blossoms which weigh down the branches of trees and then carpet the grass with a sea of pink as they fall to the ground.

27

LEFT **BLUE TITS FEEDING**
*Blue tits never stay still and, in
order to get this sketch right, I had
to study my subject long
and hard, and make several
quicker sketches first.*

The Art of Sketching

I am constantly amazed at how much I would like to put in my sketchbook, particularly at this time of year when everything seems to be happening so fast!

The art of sketching successfully comes only with practice. Gradually, you get to know what you can do in the time available – often you have no time at all and at other times you will find yourself turning what began as a quick sketch into a careful study. The more drawing you are able do, the more it will help you speed up and make sketching enjoyable.

Sketches can be put to a variety of different uses. You can make 'idea' sketches to help you put your thoughts in order before starting on a larger piece of work. Alternatively, sketches which become studies can help you to develop your techniques, as well as being preliminary drawings which help with your painting.

RIGHT **PAINTING NATURE'S DETAILS**
*The little toadstools (far right)
appeared suddenly, after days of rain,
growing in lush grass. They are
yellow cow-pat toadstools, which my
nature book describes as 'a rather
unexciting little fungus'. Growing
nearby was this lady's smock, or
cuckoo flower (near right). It was
certainly a favourite with the small
white butterfly which flitted from one
flower to the next. The flowers were a
delicate lilac colour, the leaves finely
cut and hardly noticeable. I found it
difficult to match the colour with my
paints, and felt very heavy-handed
when painting this little flower.*

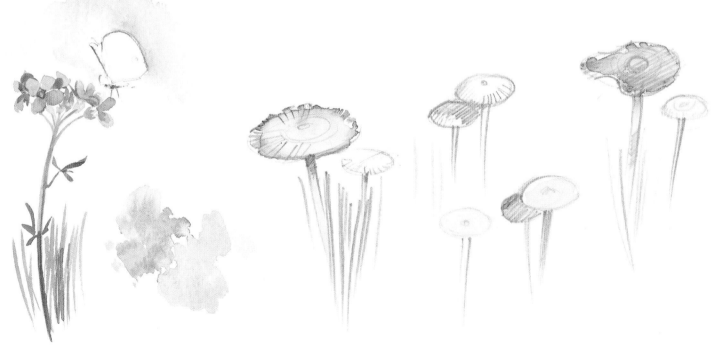

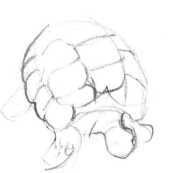

ABOVE RIGHT **TORTOISES**

These tortoises were having one of their first outings after the winter and enjoying a feast of dandelions, daisies and broccoli. I was surprised at how fast they moved – I started to draw them with a soft pencil, then looked up and found they had moved to a completely different position!

RIGHT **NESTING SWAN**

This swan's nest was built on swampy ground but was completely visible from a distance. I sketched it with a 2B pencil, but wished I had my painting bag with me as it was an imposing and colourful sight.

ABOVE **WILD FLOWERS**

I have an abundance of cowslips in my garden – I let them set seed and, although they hamper my grass mowing, I love these little flowers. This was painted on a heavyweight cartridge paper. I intended simply doing a drawing but couldn't resist using colour, and worked the sketch into quite a detailed study. The cowslips were growing in quite long grass among dandelions and the first buttercups of spring.

29

Primroses and Violets

Primroses

I painted the primroses and violets on these two pages on a lovely sunny day when spring was well under way – I could see primulas, pansies, catkins and daffodils everywhere. Bright sunshine illuminated the primroses that I had hardly noticed before, their fresh, pale yellow flowers suddenly appearing to my eye at the edge of the grass.

Sometimes, people reduce the size of the flowers they are painting, mistakenly thinking that painting on a smaller scale is easier, but it is not. Try to paint the flowers at their actual size, be generous with your paper and let your flowers breathe. Don't squash your image up to the edges of the paper in an effort to get everything in – if you work on a large sheet and allow plenty of space around the painting you can decide on margins later when you trim and mount your work.

PRIMROSES
I drew the plant quite carefully in pencil first, trying to simplify the arrangement. I used the palest yellow in my palette (a cool lemon yellow) for the flowers. The green leaves were a mixture of cerulean blue and cadmium yellow pale.

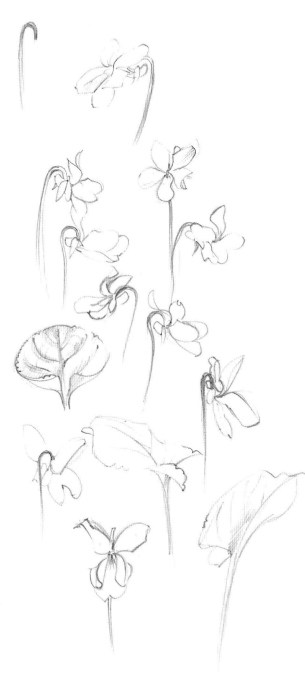

Violets

The flowers of the violet are small and secretive, not caring to show their faces. They can be hard to find unless you know where to look, and growing so close to the ground, they can be quite difficult to paint.

I make it a rule not to pick wild flowers, but since I have some violets in my garden, I picked a few so that I could draw them first close up in pencil to get to know their shapes and the way they grow, while enjoying their elusive and unmistakeable perfume. The small flowers are very delicate, and related to the pansy.

Don't forget that careful drawing always helps – to be able to draw accurately increases your knowledge of the subject and is never a waste of time.

The detailed drawings (LEFT) were made with a B pencil on cartridge paper. The paintings of the same subjects (RIGHT) were very direct, using a No. 7 sable brush and a mix of ultramarine and Winsor violet for the flowers, and Prussian blue, cadmium yellow and burnt sienna for the leaves.

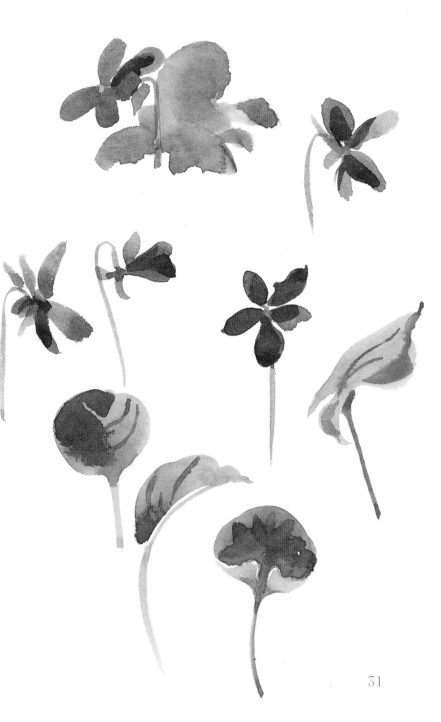

PAINTING FEATURE: The Potting Shed

OPPOSITE
THE POTTING SHED
Size approx. 33 x 43cm (13 x 17in)
Painted on Bockingford 425 gsm (200lb)

This painting of a potting shed was made indoors on a wet day in early spring. It is made up of two different parts: the still life – the pots, bricks, trowel and plants – which was set up below eye level, and the background, which was taken from a painted study of a garden shed that I had previously made in my sketchbook

The still life was lit from the left by a spotlight. After making a drawing of the whole composition, I worked my way around the painting, starting with the pots, then the bricks, and moved on to the trowel and plants. The subject demanded the use of richer reds, browns and greens in addition to my usual spring palette, and provided an opportunity to experiment with shadow colours. Note the textures on the bricks and soil – these were painted using the wet-into-wet technique (see page 16). I tried to avoid over-painting, and most of the colours used were applied directly as pure colour, without any mixing.

The interior of the shed acted as a dark foil behind the still life group, with the door and clematis providing lighter, sunny areas. The focus of the group is on the still life in the foreground, and the background is painted in less detail.

The subject could have been extended to include a wider view of a landscape behind. Use your imagination when putting together different elements to make up a composition, but try to paint as much as possible from the objects or views in front of you. Your sketchbook or journal should provide you with a rich source of material.

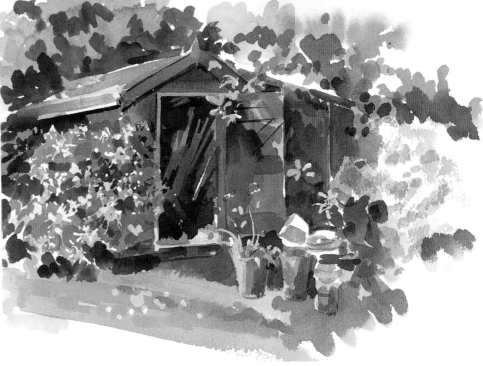

LEFT **DRAWING FLOWERPOTS**
Be aware of the basic shape: narrower at the base and wider at the top. Use construction lines to help you draw more accurately and round off the corners of your ellipses. The rim of a pot often catches the light and so should be in a lighter tone.

COLOURS USED:

LIGHT RED		WINSOR YELLOW	
BROWN MADDER		ULTRAMARINE	
YELLOW OCHRE		BURNT UMBER	
LEMON YELLOW		SEPIA	

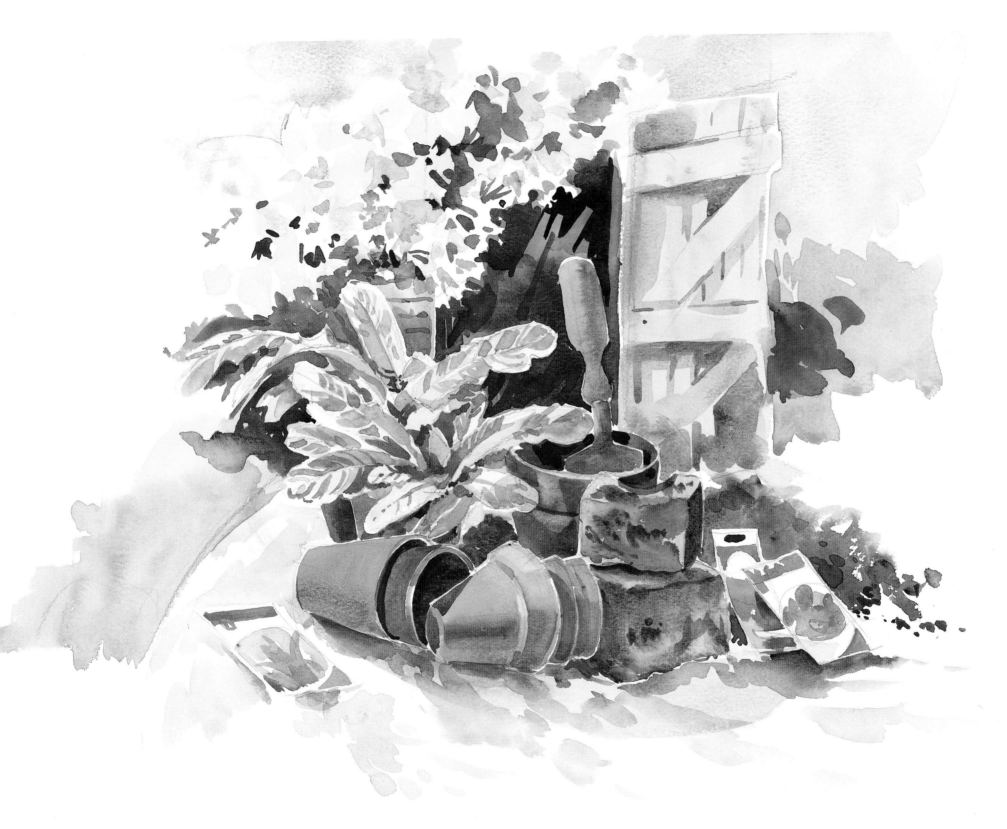

Daffodils

Daffodils are so enchanting and such a welcome relief from the dark days of winter that they make most of us rush for our paints! There are many different types of daffodil, and quite a few watercolour yellows for you to use accordingly. If you are familiar with the range of yellows available it should be fairly easy to find the right one, but shadow colours can be quite problematical. The shadows appear as greys, or green-greys, and they have to look right. If you opt for a blue – very pale and delicate – it will create a green on the yellow. An unmixed grey will usually contain a certain amount of red, so can look too brown if you are not careful, and on no account should you be heavy handed. The best solution is to mix your own greys and I find the following mixes very reliable:

- aureolin and ultramarine
- cadmium yellow pale and cobalt
- Winsor yellow and cerulean.

LEFT *Daffodils, or narcissi, come in all sizes and colours – from miniature daffodils to larger, double varieties, and from white to a deep yellow. They have a long flowering period throughout the spring – these pale narcissi were blooming in my garden in the middle of the season.*

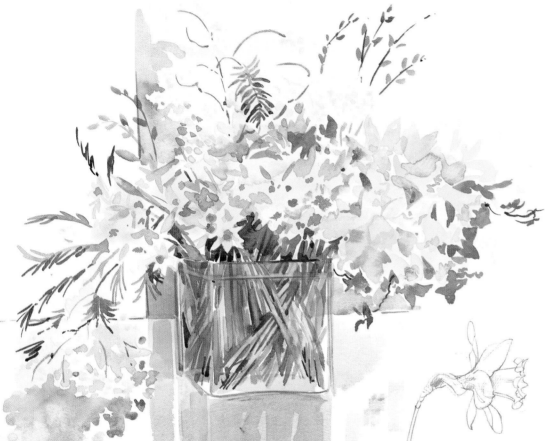

To achieve a massed effect of flowers it is best to paint the whole area, rather than to consider each flower separately. You can do this by first using a wet-into-wet technique (see page 16) – apply a pale yellow wash over the whole area. Then work wet-on-dry (see page 11) to add the darker tones of yellow for the separate flowers, and the green for the stalks and leaves.

LEFT **SHAPES AND DIRECTIONALS**

I enjoy drawing and analysing shapes and directions. With a daffodil, you can simplify it to its basic shapes and look for the spaces between the petals. The leaves curve in interesting ways – try to make a good sweep of the pencil to achieve a sinuous line.

Drawing Daffodils

Getting the shape of the daffodils right should not be too difficult. The trick is to concentrate on the basic shape of a sphere combined with a trumpet or cylinder. The petals can be drawn reaching out of the sphere or ellipse, and all the details added after. Daffodil leaves are ribbon-like and twist around. They are best captured with long, light strokes of the pencil.

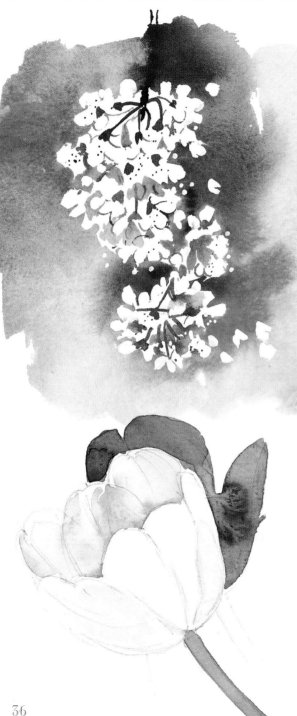

Painting White and Pale Flowers

During spring, I am always entranced by the many shrubs in bloom, and often use them as subjects to brush up my painting skills. Many of their flowers are white or pale pink which can create a problem for the artist. One method of painting them is rather like painting in reverse – leaving the white of the paper to make the flower, so that shadows and backgrounds become all-important in defining the shapes (see page 16). You will find that this is a useful method that you will use time and time again when painting flowers.

With smaller flowers a masking-out technique can be used. Paint the flowers with masking fluid (a rubber solution) then, when it has dried, paint the background. When the background is dry, rub off the solution to leave the white flowers. However, this isn't always satisfactory and the final result can leave rather a hard edge.

Flowers are always influenced by their surroundings, and this is particularly evident when painting white flowers. Flowers are usually seen against backgrounds of green foliage, which can be confusing to the eye, but there are many different shades and variations of green to make viewing them easier. If you are clever, you can sometimes dispense with green altogether! Why not try blues and yellows, and let them mix on the paper.

Painting flowers set against a plain background is comparatively easy, but painting the same flowers in a real situation is much more difficult. Although time-consuming and painstaking, it is relatively easy to achieve a good result through absolute realism. But to achieve a fresh and spontaneous result, you have to paint convincingly to suggest light and shade, shape and form so that the onlooker can fill in the parts that you leave out.

Tulips

Tulips hold a great fascination for me –
they provide colour in the garden, and
are delightful in the house. They twist
and turn towards the light and you have
to be quick to paint them, particularly if
they are in a warm room.

Tulips are simple goblet or cup shapes.
You can find them in a tremendous
variety of colours from white to purple
and almost black. The leaves are a
particular soft green and sword-shaped.

I have listed below some mixes for
greys which you may find useful in
flower painting:

- Permanent rose, cobalt and
 cadmium yellow
- Cerulean and light red
- Ultramarine and brown madder
- Permanent rose and magenta
- Permanent rose and cobalt.

TULIPS

*These tulips were a pale, creamy colour and needed
a light touch to convey something of their delicacy.
The shadow colours need to be studied and it's worth
spending a little time trying out variations of grey
–you could try both warm and cool greys. In this
painting I used a mix of cerulean and light red to
achieve the subtle greys required.*

Painting the Landscape

BELOW *This watercolour sketch would be very useful as preparation for a larger piece of work.*

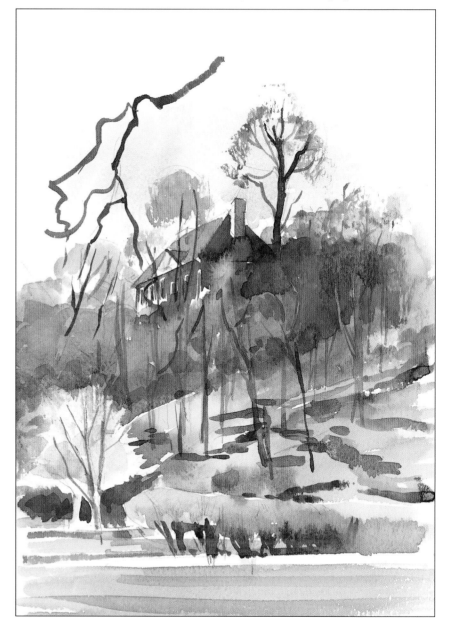

As soon as the weather warms up in the middle of the season, I love to get out with my paints, but before I go out I will have noted painting sites on my walks and taken into consideration the way the sky and light are changing, and how this affects the landscape. For example, a low afternoon sun can create dramatic effects with long shadows, and early morning light can be mysterious and soft. A grey dull day tends to flatten the subject, but strong sunlight is marvellous, bringing the countryside to life.

Many would-be artists are wary of landscape painting. Considerations such as the need to be outside, possibly in cold weather, shyness of working in public view, and loneliness all have to be taken into account. Painting on holiday, when you are relaxed and have plenty of time, can be a good time to start.

In the landscape, you are faced with the big wide world and have to learn to make decisions about your subject – what view to select, what to focus on and how to tackle it. You could concentrate on certain areas, such as skies and trees, until you are able to put down your landscape ideas with ease. You will need to know what colours to use and the best ways to use them. Know your blues and greens and be able to use your brush with confidence. If your first efforts disappoint you, don't be discouraged – practice and perseverance will pay in the end. Don't tackle anything too large, and try to avoid too much detail.

ABOVE *I made this pencil sketch of a tree to work out areas of light and dark.*

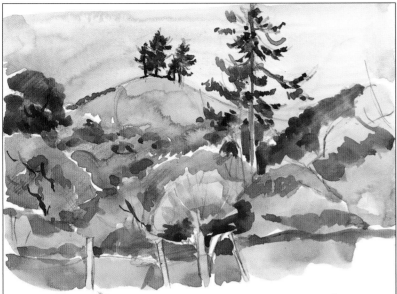

RIGHT *If your landscape includes animals, remember to keep them at the right scale. I saw these lambs at a distance, across a field. They didn't stray far from their mothers, probably because it was so cold on that day.*

BELOW *A larger sketchbook study of a Sussex scene.*

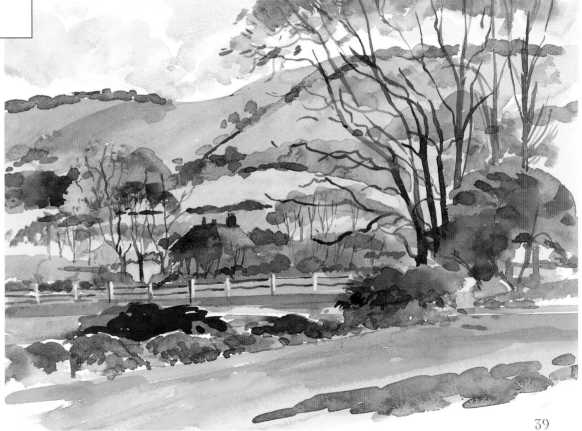

ABOVE *Two 'idea' sketches, noting the colour and arrangement of each scene, taken from my sketchbook.*

39

PAINTING FEATURE: Spring Landscape

It was a bright day in late March – there were hints of green all around, and the sun was casting long shadows. The winding lane with its bright grass verge attracted me initially, and after making my thumbnail sketch I decided to make an upright (portrait) painting, which is unusual for a landscape. Although the day was quite sunny, it was cool so I wore a thick coat and boots and took gloves, a hat and a scarf – also coffee. It is best to be as comfortable as possible!

Use a viewfinder and make small sketches to determine content and proportion. Your small (or thumbnail) sketch is an 'idea' sketch – use it for putting your thoughts on paper, like scribbling on the back of an envelope. Try to get the proportions correct, but at this stage you can always alter things, or start again, and often your initial sketch will tell you what not to do. If you have time you could put tonal values in, maybe even some colour. Once you are satisfied with the composition, measure and check the proportions again.

Having already decided on the composition you should find it easy to transfer your idea sketch to larger paper. Draw lightly with a pencil and then start painting.

Remember that light is an important factor in landscape painting and your subject can look quite different at different times of the day, so if you start painting in the morning, don't continue in the afternoon as the shadows will be different. If you decide to stay at the same site all day, start a different painting after lunch.

BELOW AND RIGHT *I found the view I wanted and made several thumbnail sketches of the scene, defining the edges with a rectangular retaining box, in both portrait (vertical) and landscape (horizontal) positions. I kept an open mind about the composition, and used a viewfinder to place the various components (see page 9).*

BELOW *Originally, I thought the format should be horizontal but there was a considerable amount of uninteresting greenery to left and right. I decided to place the barn more or less in the centre of the composition so more of the trees could be seen.*

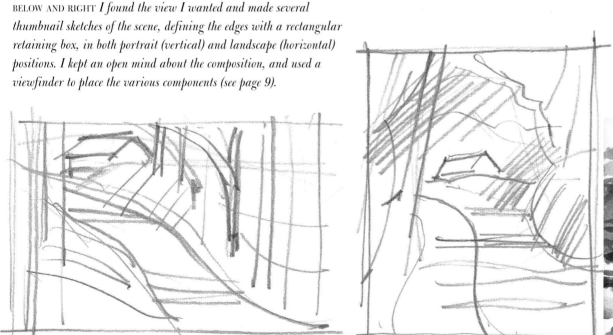

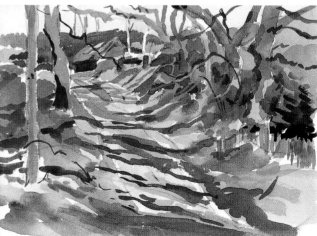

COLOURS USED:

COBALT	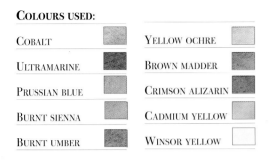	YELLOW OCHRE	
ULTRAMARINE		BROWN MADDER	
PRUSSIAN BLUE		CRIMSON ALIZARIN	
BURNT SIENNA		CADMIUM YELLOW	
BURNT UMBER		WINSOR YELLOW	

RIGHT
COUNTRY LANE
Size approx. 37 x 28cm (14½ x11in)
Painted on 300gsm (140lb) NOT Arches paper,
using Nos. 12 and 6 sable brushes.

I painted the larger areas of the picture first, starting with the
sky, then the lane, followed by the various masses of foliage
and colour areas before adding any detail. I was careful to note
the lightest and darkest areas and to achieve the correct depth
of colour. I stood at an easel to work and took about two
hours to complete the painting.

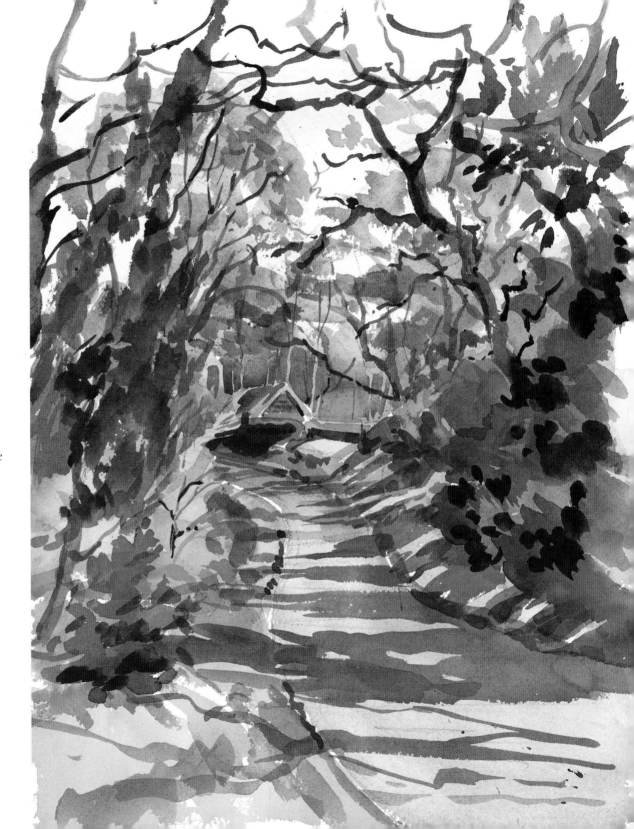

Blossom Time

Towards the end of spring you can be overwhelmed with subjects for painting, but one aspect of the season that never fails to excite me is the flowering cherries – such lovely trees with gorgeous blossom which often weighs down the branches, then the spring winds scattering the blossom over the garden like snow.

I wrote earlier of painting flowers as a mass (page 35) and flowering cherries need to be painted in the same way. Paint the whole area of blossom in one wash, then add detail to the flowers later. I like to use my No. 12 sable brush with a great deal of water, and enthusiasm! There are other kinds of blossom which are fun to paint, such as lilac and apple blossom. Trees in full blossom are difficult to paint in watercolour, so it is probably easier to start by painting a detail of the tree to find one's bearings, such as one or two branches or twigs.

ABOVE *This flowering cherry borders a field near my home and was painted in watercolour on Bockingford paper. I had to work broadly to capture the frothy effect of the petals.*

BELOW *Apple blossom, painted in watercolour with pencil on cartridge paper.*

LEFT *A study of a double-flowering cherry blossom in water-soluble coloured pencils.*

RIGHT *Apple blossom is enchanting. It is both pink and white and combines with the pale green leaves and dark branches to make an intriguing subject for the watercolourist.*

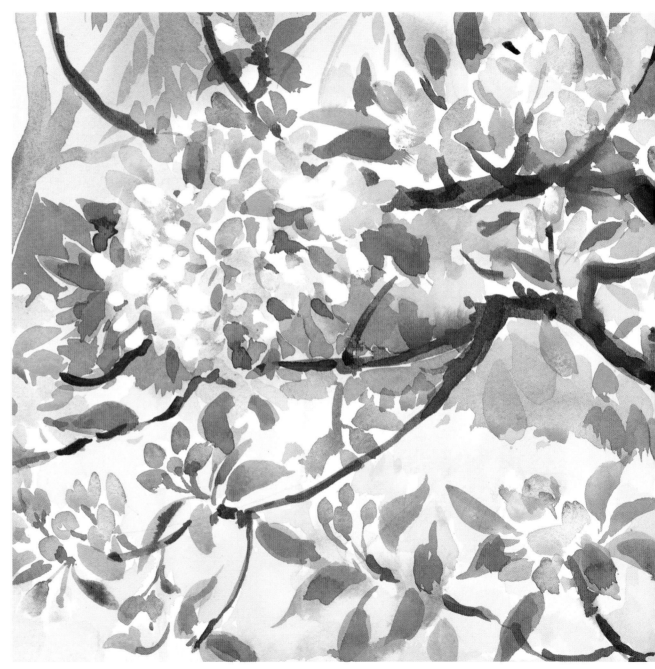

BELOW *A sketch of white-flowering cherry blossom – note that it is the background which defines the white blossom.*

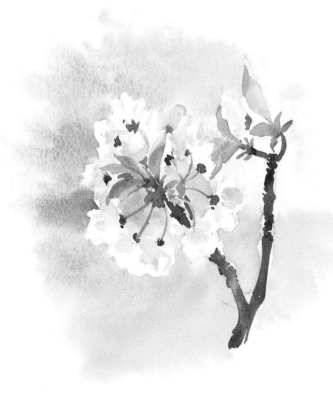

Bluebells

Bluebell flowers

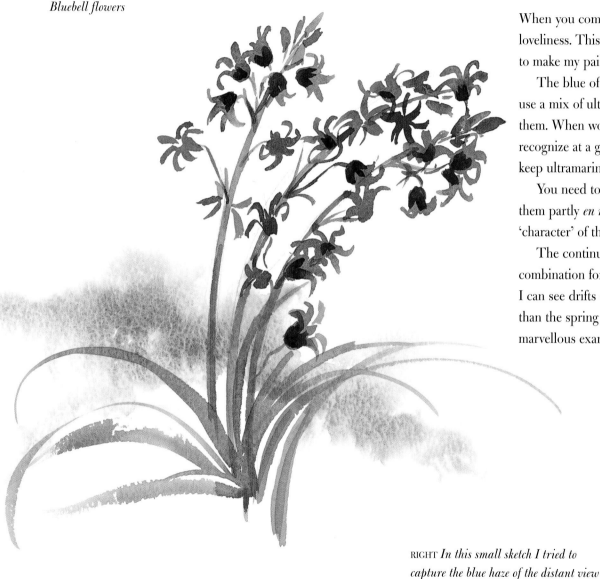

When you come across bluebells in a wood, they take your breath away with their loveliness. This year the bluebells were earlier than usual and by the time I came to make my painting they were almost over, but still beautiful.

The blue of these flowers is elusive – partly blue, partly violet – and I tend to use a mix of ultramarine and a blue red, such as alizarin crimson, for painting them. When working in watercolour, you must know your blues, and be able to recognize at a glance which blue to use, or what mix to make. In my palette I keep ultramarine, cobalt, cerulean, Prussian blue and indigo.

You need to combine various watercolour methods to paint bluebells, painting them partly *en masse,* and partly in detail. Generally speaking, I try to capture the 'character' of the flowers.

The continuous wet weather interspersed with sunshine is a happy combination for many plants. When I look around my garden at this time of year, I can see drifts of blue forget-me-nots which are an intense cobalt blue, deeper than the spring sky. The lilac and ceanothus are also in bloom and are further marvellous examples of blue and violet.

RIGHT *In this small sketch I tried to capture the blue haze of the distant view of a mass of bluebells in a beech wood.*

BLUEBELL WOOD

I initially dampened the paper and dropped in a mixture of ultramarine and permanent rose – I also used cobalt as I wanted to achieve a brilliant blue. I mixed a light, soft green and used this to indicate leaves and grass. The bluebell flowers were painted when these washes were dry, using ultramarine and permanent rose of various strengths. The trees and background were painted next, then the various stalks and leaves.

45

Garden visitors

If you are a keen gardener, you will find less time for painting in the later part of spring, but the longer evenings are often ideal for sketching. The garden has that burgeoning feeling and you will find that there will be more flowers than you will have time to sketch! Of course, the garden also attracts visitors and the lengthening evenings of late spring can be used to look out for and capture one of these on paper as they make their regular visit.

Dusk is a good time to try to spot a fox in the garden, or if you are lucky, a badger in more rural areas. Some animals such as moles, shrews or mice are so elusive that the only way you might see one is when it is dead. However, drawing from deceased specimens is a useful way of making a record of animals, enabling you to study them in detail.

LEFT *Gardeners often stay in the same position, or repeat positions a lot, making them easier to draw. Go for the main shapes and the general directions of the limbs first.*

ABOVE *My cat was watching these seedlings grow, so I took the opportunity to make a watercolour sketch before she moved and the sun disappeared.*

LEFT *It isn't often you see a mole. There are numerous molehills in my garden but, in spite of my cat's efforts, the moles stay well out of reach, underground. This one was found dead, sadly, by a neighbour and I took the opportunity to make a quick sketch, noting the soft smooth fur and the digging paws which seemed to come from the shoulders, and how much smaller it was than I had imagined.*

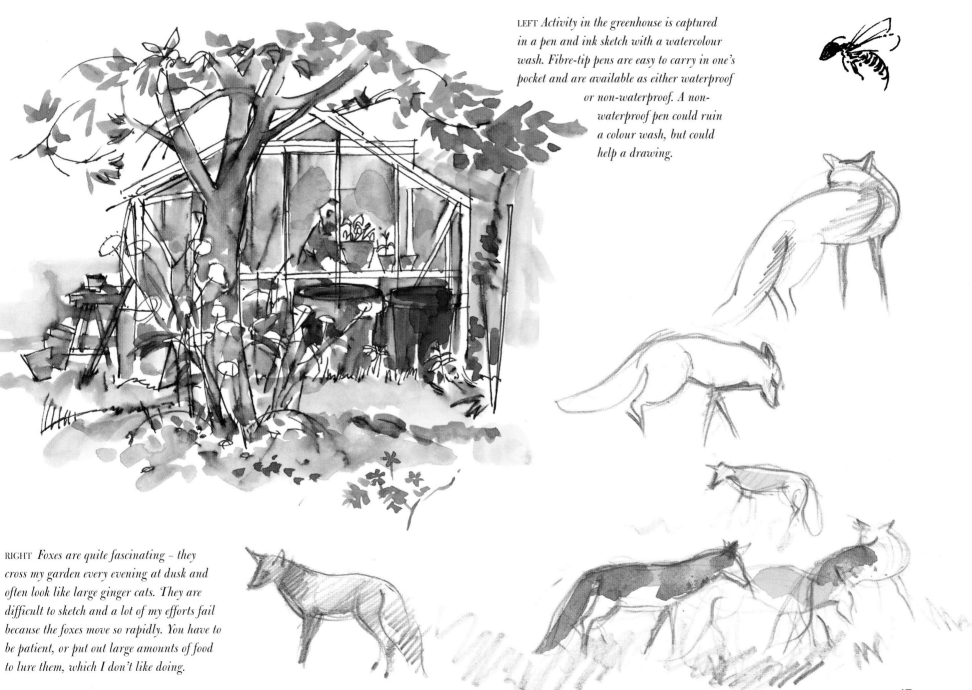

LEFT *Activity in the greenhouse is captured in a pen and ink sketch with a watercolour wash. Fibre-tip pens are easy to carry in one's pocket and are available as either waterproof or non-waterproof. A non-waterproof pen could ruin a colour wash, but could help a drawing.*

RIGHT *Foxes are quite fascinating – they cross my garden every evening at dusk and often look like large ginger cats. They are difficult to sketch and a lot of my efforts fail because the foxes move so rapidly. You have to be patient, or put out large amounts of food to lure them, which I don't like doing.*

SUMMER

Summer is here and the garden is full of flowers – the iris are in full bloom, the lilacs, both purple and white, are lovely. Wildflowers are much in evidence – on warm days you can literally watch the flowers grow. The days are long and full of activity.

The trees are in full leaf, and I am again reminded that they are easier to paint during the winter when there are no leaves. However, I have made up my mind to check my greens, and to think of basic tones. There are so many variations; you can use ready-made greens such as sap green or Hooker's green, or you can mix your own from blues and yellows.

SUMMER SKIES

The clouds were changing constantly and by the time I had painted the second sketch it was obvious we were going to have a heavy shower – birds started flying in all directions. The sky (LEFT) was painted using cobalt with cerulean near the tree line. The clouds were a mixture of cobalt and brown madder, ultramarine and burnt sienna. The second sky (ABOVE), painted a few minutes later, omitted the cerulean. There was a slight off-white look to the clouds but, when making these rapid sketches, I had no time to consider this.

Nature's Palette

The colours of summer are more strident than spring colours, and although soft colours remain, I am starting to see deeper blues, stronger pinks, reds, purples, and, of course, greens. The yellows, however, are less obvious than they are in spring. There are also white flowers at this time of year – hawthorn bushes are covered in a mass of white blossom.

Gamboge

Gamboge plus ultramarine

Cadmium red

Permanent rose

Winsor violet

Ultramarine

RIGHT *I have used the brush in quite a free manner for this landscape sketch made in Ireland; most strokes are horizontal with just a few diagonal strokes to indicate the riverbank – I wanted to capture the green and flat countryside.*

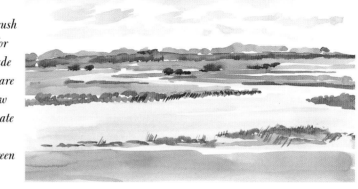

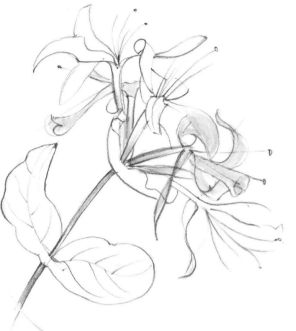

HONEYSUCKLE

The scent of honeysuckle is delightful. These complex flowers spring from perfoliate leaves (leaves that are fused together around the stem).

CAMPION

Campion grows in my hedgerow and is a delightful shocking pink. I keep looking for a white campion, but it is not as common as the pink.

Working with Watersoluble Coloured Pencils

If you like the idea of using watersoluble coloured pencils, you will find there is an amazing array of colours to choose from. I use about 15, and keep them well sharpened. (Crayons that dissolve in water are also available, but these are suited to larger work.) Although the colours can be dissolved with water and a brush, they can also be blended by cross-hatching. Do try them out first, and use a fairly heavyweight cartridge which won't cockle as much as a lighter weight paper. These pencils perform better on a smoother surface. For the selection of summer flowers shown on this page, I added colour to a 2B graphite drawing of the vetch and the honeysuckle, but started with coloured pencils for the campion.

VETCH

Vetch is a small climbing plant that scrambles among the cultivated flowers in my garden and is quite decorative with its tendrils and small purple flowers.

49

Ideas for Summer Painting

Warm days, bright sunshine, shadows, trees in full leaf, hazy landscapes – what a host of subjects are available for the watercolourist! We can paint in the warmth of the sun, or in the shade of woodland. Life seems easier and less rushed and we can take more time on our painting during the longer days.

We have many flowers to contemplate, from foxgloves to roses. Artists have to be very observant and to notice nature's many changes. Recording by drawing and painting is an ongoing activity but if you miss a subject you will always be able to return to it the following year.

Summer is holiday time for most of us, and this can give the opportunity to paint different subjects – you could find yourself painting by the sea, or beside a lake or in the mountains.

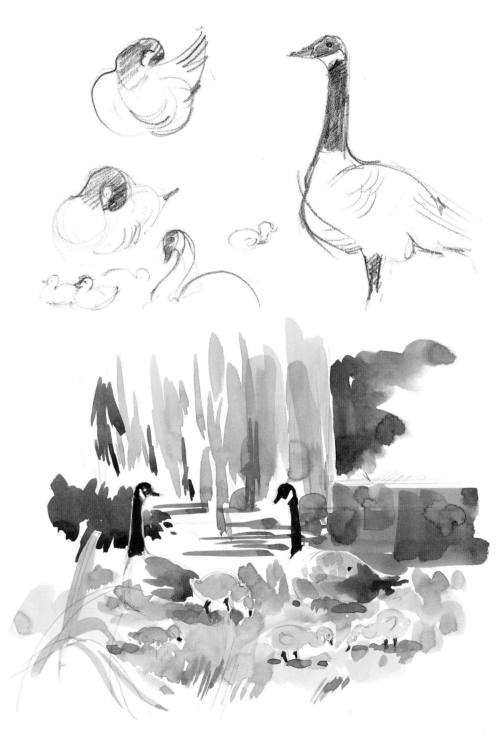

RIGHT *Canada geese are frequent visitors to my garden and often bring their families with them, standing guard to let the goslings graze. I started with some sketches made in conté crayon and then used watercolour.*

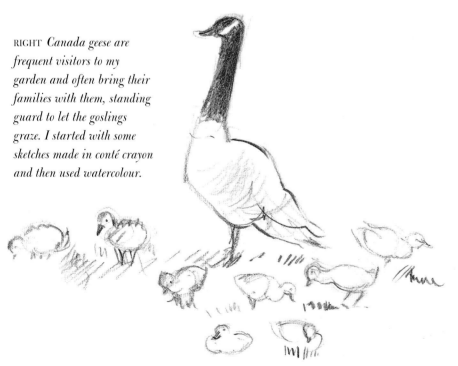

50

DANDELION CLOCKS

*The simple, delicate globe
shapes of dandelion clocks are
lovely to paint, and buttercups
and Queen Anne's lace (cow
parsley) make good companions.
The dense grassy areas in the painting
were resolved by dampening the paper
and dropping the colour in, then once the
paper was dry, the grasses were painted on
top. I didn't use masking fluid, but no doubt
it would have helped. The greens were made
from ultramarine and gamboge, Prussian
blue and burnt sienna, and I used gamboge
for the buttercups.*

Summer Flowers

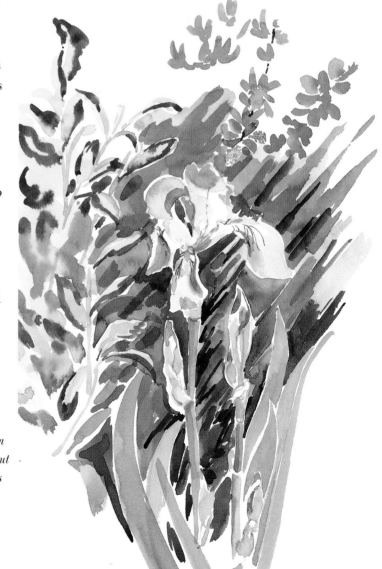

June is a marvellous month for painting flowers. I have a choice in my garden of iris, poppies, delphiniums, campanulas, alliums and many more. Also, there are wildflowers such as the ox-eye daisy which, when combined with cultivated flowers, are most useful and attractive in a border.

I often start by making studies in order to match colours and to gain the confidence needed to tackle a larger painting. I find it helps to paint the flower at its actual size and to be careful about using pure watercolour (that is, unmixed, except on the paper). Magenta, permanent rose and Winsor violet are particularly useful for flower painting, as are various oranges – cadmium orange and cadmium yellow deep may just be the colours you need when painting marigolds or sunflowers.

Painting flowers in a garden can be more difficult than painting them in a studio, as you do not have control over composition or light, and you could find yourself sitting in the middle of a flowerbed, or in some other awkward spot. Standing at an easel is often best, but you may have to adapt to the situation to suit your needs.

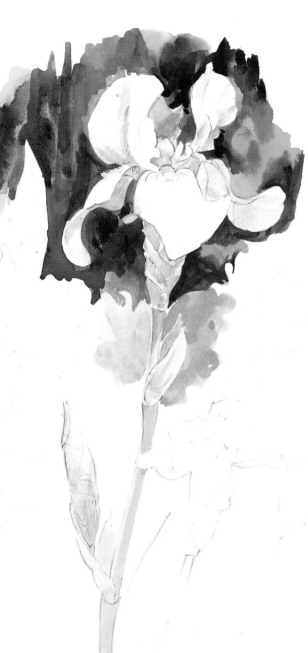

LEFT AND RIGHT **IRIS**
This is quite a careful rendering of a white iris (left), drawn on hot-pressed paper. I had intended to go further with it, but lack of time prevented me. In contrast, the lilac-coloured iris (right) was very freely painted.

BELOW *Garden flowers take quite a lot of looking after and even perennials can require dividing up, dead-heading and nurturing, unlike wild flowers which just have to take their chance. The iris, for instance, is fairly trouble-free, but snails can eat away the buds and rip up the leaves. This lupin was completely devoured in its third year and this painting is the only record I have of it.*

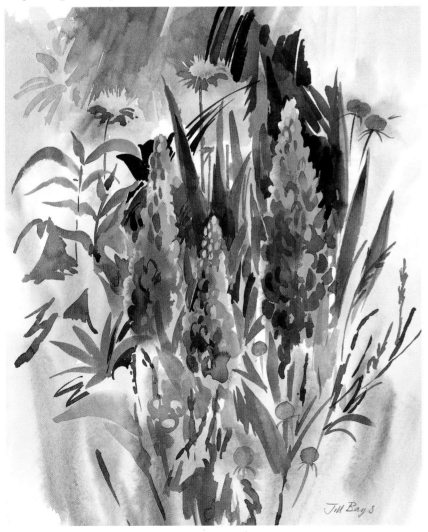

Jill Bays

ABOVE *This French lavender (Lavandula stoechas) is very fragrant and loved by bees.*

RIGHT *Shirley poppies are delicate with tissue-paper petals, their shapes are simple and the colours glow. These were drawn with a fine dip pen and Indian ink. Try drawing them in pencil and paint them in watercolour.*

ABOVE *Snails are interesting creatures and amusing to draw. They move surprisingly quickly, their shells rocking gently. I found pink, yellow, striped and the larger black-brown snails. After light rain at night, you can often find hundreds in the garden – it is a wonder there are any flowers left. These common and striped grove snails were drawn in pencil with some watercolour pencil.*

53

Trees

Knowing how to paint trees involves knowing how to paint all the individual elements – leaves, trunk and branches – as well as the whole tree. What better way to start than by drawing – using both a pencil and a brush. Many leaf shapes are simple brushstrokes and all trees have a linear content in their twigs and branches.

I suppose that many students who find difficulty with trees are concerned with the mixing of green. As I write this, I can see various trees whose colour ranges from a light yellowy green through to a blue-green, a silvery green, and the dark green of a Scots pine. Try some of the mixes shown on this page.

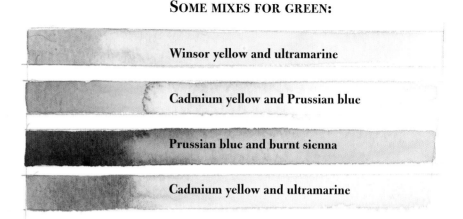

SOME MIXES FOR GREEN:

Winsor yellow and ultramarine

Cadmium yellow and Prussian blue

Prussian blue and burnt sienna

Cadmium yellow and ultramarine

BELOW *If you are painting the whole tree, think of the characteristic mass and silhouetted edges – whether spiky, rounded, soft or pointed. This row of distant trees in a park was painted directly without drawing first (using the green mixes shown above), showing how varied the shapes, the sizes and the greens can be.*

LEFT *There are many different leaf shapes – long, narrow willow leaves, spiky holly leaves, large divided chestnut leaves and small silver birch leaves – all these can be made easily with your brush. If you find curling leaves difficult, you can practise drawing them with a pencil, following the shapes through so that you don't get confused with the different edges (think of drawing a ribbon if that makes it easier).*

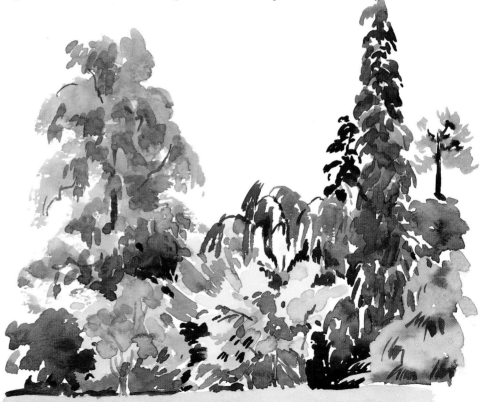

BELOW *Here are some distinctive leaf shapes using the colours shown in the palette opposite. From left to right: silver birch, willow and holly.*

BELOW *To me, the white froth of hawthorn blossom is a sure sign of summer. It is sometimes called 'may' or quickthorn, and there are several superstitions surrounding it. This painting shows part of an old hedge system. Using watercolour, I painted straightaway with a brush, indicating some of the blossoms with a pencil. The gate and field were added later.*

LEFT *Tree trunks are very distinctive – some are smooth, others are rough and deeply serrated. They are often green and grey, some can be reddish brown. This tree was drawn in conté pencil.*

55

Gardens and Picnics

Painting in a garden is a delightful experience – warm sunshine and flowers make a good combination. There are so many types of garden to explore, from those belonging to grand stately homes to small cottage gardens, or why not try sketching the plants at a garden centre?

There are, to my mind, two approaches to painting in a garden. You can zoom in on particular flowers, making these the largest component of your painting, and then suggest distance by a hint of further landscape. Alternatively, you can treat the garden as an enclosed landscape, finding a centre of interest to focus on and working out from there. While there is no substitute for direct observation, you can take photographs to back up your sketches and then work on your finished painting later.

Of course, garden painting offers a very wide range of subjects, from vegetables to flowers and fruit, ponds, greenhouses and all the paraphernalia of gardening – pots and patios, watering cans, tools – the list is endless.

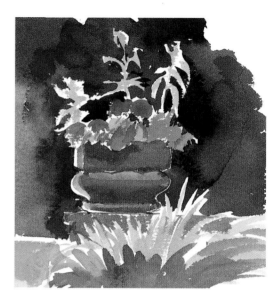

RIGHT *In summer the light is brighter and enables you to appreciate strong tonal values. This container was strongly back-lit and threw the plants into prominence. Darks are quite hard to achieve – I don't use black, and try to give my darks some tone and colour, however dark they are. Try mixing Prussian blue, alizarin crimson, and burnt umber or ultramarine, and burnt sienna. Don't forget to use a lot of pigment to achieve the strength of tone required.*

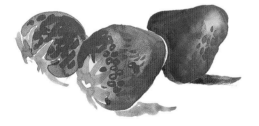

RIGHT **PICNIC IN PETWORTH PARK**
If you are having a picnic, there is often time to sketch. While in Petworth Park in Sussex, I had glorious views of the parkland, but it was the animated picnic group that fascinated me. Once the party was settled, they didn't move a great deal, and they stayed still long enough for me to draw in the main shapes in pencil. The light figures against the darker trees were appealing, so the figures were painted first followed by the trees, the grass and then the distance.

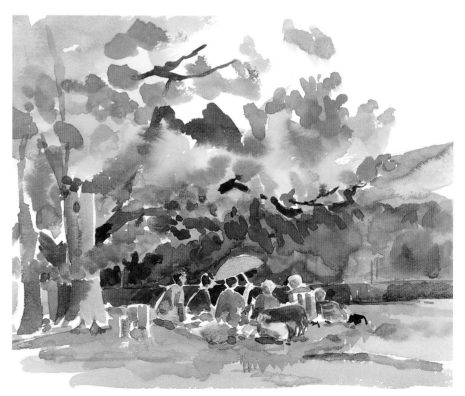

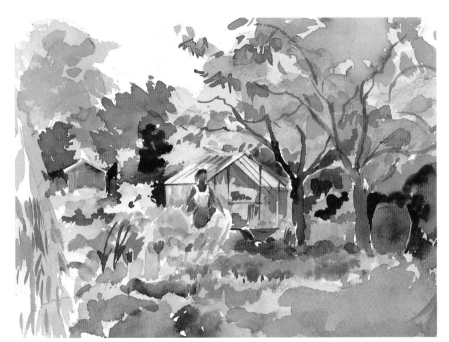

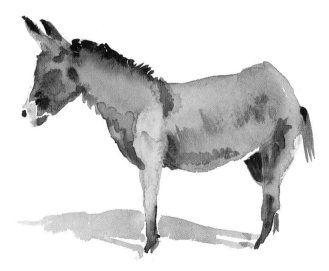

LEFT *This little painting shows part of a garden and is more of a landscape painting. There are a great many different greens, and the use of a figure is helpful in creating a focal point.*

BELOW **POPPIES**

This illustrates the first of my two approaches to painting in a garden that I have described on these pages. The flowers are the largest component, and the distance is suggested by the trees. The poppy formed a focal point and there is a diagonal feeling to the composition which is helped by the direction of the dark shapes.

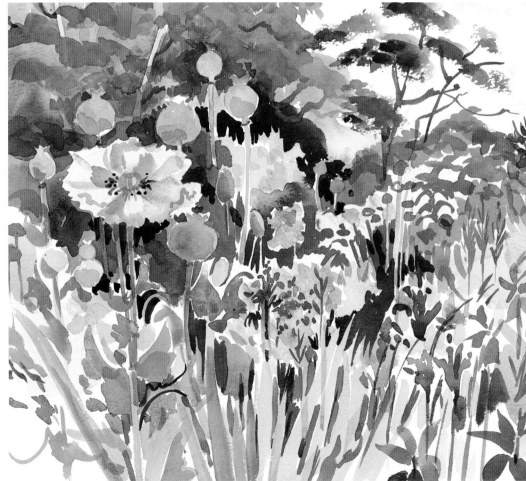

ABOVE *This friendly donkey was sketched on a nearby farm in pencil, and watercolour was added in the studio. It is helpful to take colour notes when sketching in pencil.*

57

PAINTING FEATURE: Painting on Holiday

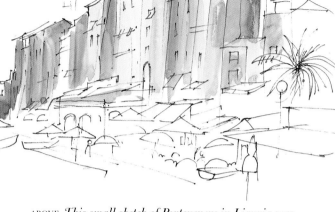

For many people a holiday provides a real chance to find the time to paint and sketch and to explore new subjects. I love looking through my sketchbook after a holiday – what memories it conjures up! Holiday painting can take various forms, perhaps it could be an organized trip with tuition or something you can do on your own, but invariably it is enjoyable and will provide as much pleasure as your photographs. I like to take with me an A4 sketchbook, a small box of watercolour paints, three brushes (Nos.12, 8 and 5), two pencils (2B and 3B), two pens (non-waterproof and waterproof fibre-tip) and a collapsible water pot.

How to start? To build up your confidence, sketch anything and everything – people, dogs, cats, buildings. Sketching requires a speedy response, particularly when other factors, such as heat, sun, people or incoming tides, play a part. Try to sit with your back to a wall, or in a corner – you could start early before people are out and leave the middle of the day to sun worshippers! You may prefer to paint in the evening when it is cooler, and shadows are longer. As always, be aware of the direction of light, note your eye level, and don't forget to measure.

ABOVE *This small sketch of Portovenere in Liguria was drawn with a pen with watercolour washes added to give an impression of the ice-cream colours of this part of Italy.*

BELOW *Lizards bask in the sun and suddenly dart away, so you have to be quick and make small sketches. In this sketch I had wanted to achieve the effect of the texture of the wall, but was so fascinated by the lizard that I could see no detail in it at all.*

BELOW *Rose madder genuine and tints of cadmium red were used to achieve the glowing pinks and reds of this brilliant geranium. When these colours had dried, the dark background was painted to define the shapes of the flowers.*

LEFT *On a luxuriant hedge of passion flower, I thought that the green leaf on the flower was a leaf until it twitched. It was a large cicada exactly the same colour as the bud. I was able to draw it before it suddenly leapt away, making me jump.*

COLOURS USED:

ROSE MADDER

ALIZARIN CRIMSON

COBALT

WINSOR YELLOW

PRUSSIAN BLUE

BURNT UMBER

BURNT SIENNA

On my holiday to Portavenere in Italy, the colours of the buildings and the different types of Mediterranean flowers were wonderful to paint. If I can't find an ideal viewpoint, sometimes I just make a start anywhere and let the drawing develop. I quite often use the contour method of drawing, building up an image by drawing around the shapes as shown in the sketch of the buildings. I also like to explore the marks that my brush can make bydrawing leaves and flowers directly with the brush, building up to a detailed flower study with no preliminary drawing.

BELOW **BRUSHSTROKES**

It is fun to paint directly on the paper with a brush without drawing in pencil first. Here I used a No. 7 sable with a good point, and a smaller (No. 4) brush for other detail. You could mix several washes using the colours here and practise making the shapes without drawing in pencil.

ABOVE **BOUGAINVILLAEA**

This brilliant, shrubby plant grows in profusion in Mediterranean countries. To a northener's eye it is bewitching. The bracts themselves are brushstroke-shaped, so my painting could be quite direct. I used rose madder and alizarin crimson with a touch of purple which I made with rose madder and cobalt. Size approx. 36 x 44cm (14 x 18in) Painted on Bockingford 300gsm (140 lb)

By the Sea

If you live in the town or countryside, anything connected with the sea is interesting – the sight of an uninterrupted horizon and the meeting of sea, sky and land, the happy hours spent beachcombing for shells, or simply messing about in boats. There is always a lot of activity by the sea – whether it is people lazing on the beach or enjoying watersports, or fishermen hard at work unloading their catch in the harbour – giving plenty of opportunities to include figures in your paintings.

Figures will give your work life and interest, and sketching people can be great fun. I usually start with the head or a main directional line, and model the figure around these. Forget details such as hands and feet, but see how the weight is distributed, and look for the angles of the shoulders and hips and directions of legs and arms. Don't use an eraser – either keep going or start again.

BELOW *This sketchbook study shows how the dark trees have been used to make the shapes of the sails of the windsurfers. The sky is rather stormy (with some Naples yellow in it) and the water is very lightly treated.*

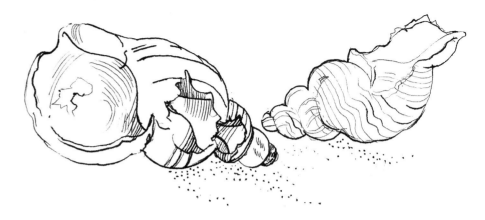

ABOVE *These shells were drawn with Indian ink and a fine dip pen which can give quite good detail. They were drawn actual size on cartridge paper.*

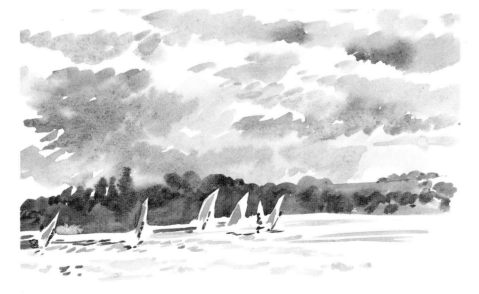

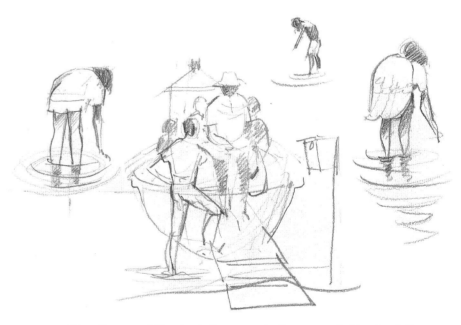

ABOVE *These figures paddling in shallow water in Devon were looking for shells. Small sketches such as these often provide useful reference material for painting compositions – nothing is ever wasted.*

KINGSBRIDGE, DEVON *This painting is from one of my larger sketchbooks. You have to work quickly when putting in figures if you are working on the whole composition on the spot. Alternatively, you could draw the figures in your sketchbook and add them to your painting later.*

Water

People are drawn to water. Lakes, rivers and the sea are always fascinating and provide interesting subjects for the artist. Painting water is often a test of a watercolourist's skills and the whole range of techniques, from drybrush to wet-into-wet, will be needed.

Don't be tempted to copy from books – go out and find a river or lake and make studies. Painting water is like painting the sky in that it is always changing, so once you have made a start, stick to your first impressions if possible.

Water can be still and provide mirror-like reflections or it can constantly move and sparkle in the sun. Reflections are always vertical and the length and shape of the reflection is influenced by the movement of the water. Often the reflection is slightly darker than the object it is reflecting. The colour of the water can also be influenced by its depth, or by the colour of the floor (sand or mud, for instance). Waves and sea-spray need a lot of studying.

ABOVE AND BELOW *Use your brush to advantage – practise with both small and large brushes to capture ripples, waves and movement. Drybrush is very effective for painting shimmering water, but the amount of water used is critical – too much or too little water on your brush and you won't achieve the effect you want. Try out your strokes on a piece of spare paper and remember to keep them horizontal.*

RIGHT *Some seemingly insignificant plants and grasses found by the sea are really very interesting and can be quite decorative. I drew this plantain and sorrel with graphite and coloured pencils.*

ABOVE *This cow parsley by the sea was drawn in ink.*

THE RIVER, EARLY MORNING

It is easier to paint the river in the early morning than later in the day when the water is disturbed by motorboats and other craft. However, a disadvantage of painting before breakfast is that the paint takes a long time to dry in the damp air, sometimes resulting in unwanted wet-into-wet effects.

Summer Landscape Ideas

The warm weather of summer is so conducive to landscape painting. But first you have to decide where and what you are going to paint, which could depend on how far you will be walking and how comfortable you are.

On these pages you can see various ideas or 'roughs' that I make before starting a painting. They help me to make decisions and are about 75 x 100mm (3 x 4in). At this size they are quick to do, allowing me only to draw the main shapes and not be distracted by detail; I then add tone and make colour suggestions.

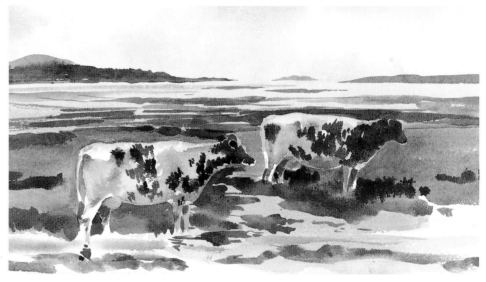

ABOVE *Animals can add interest to a country scene. These cows obligingly stood quite still long enough for me to draw them carefully in pencil before painting them in watercolour.*

BELOW *As well as making pencil studies, it is useful to try small colour ideas, such as this small garden landscape, before embarking on a larger piece of work. As well as helping with colour, a sketch such as this will help with organizing the composition.*

Drawing Sight Size

When drawing a landscape, it is important that the distance actually *looks* distant. Most people make it appear too near and too large. One way to overcome this is to draw 'sight size', which is easy to do. Measure an object in the distance – a house or tree would do – with your arm outstretched, and note the size with your thumb on your pencil. Transfer this measurement to your paper and draw it. Do the same with other parts of your landscape and you will find that everything is in proportion. Soon you will find that you will be able to judge sizes more accurately.

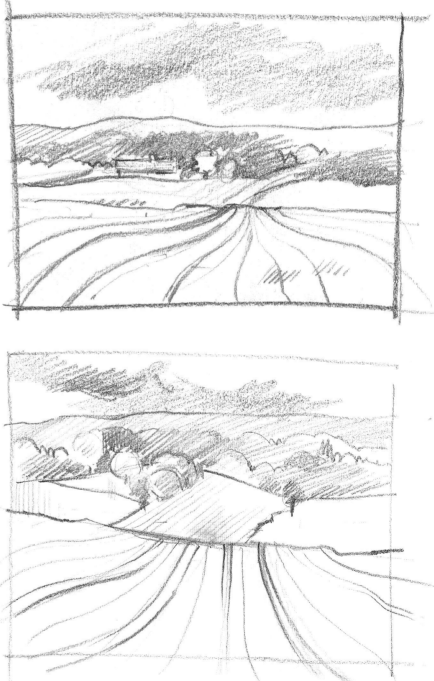

ABOVE *A tonal scale in black and white can be helpful. It will determine the range of tones available and can be compared with your subject by checking your darkest and lightest areas.*

LEFT AND RIGHT *I was attracted to this open view by the sky, the distant hills and by the converging lines in the foreground field, and subsequently made three rough sketches of the same subject. I preferred the landscape format to the portrait or upright idea. It is quite surprising how different a scene will appear if you turn your head even slightly to the left or right instead of looking straight ahead of you. Also experiment with different eye levels – if you stand, you will have a different scene from one where you are sitting. Don't forget to measure if you are at all unsure of your drawing proportions.*

PAINTING FEATURE: Colour Ideas

ABOVE *When you are painting, you often become very aware of certain things happening around you. This fat pigeon interested me, as well as the two crows; one was a youngster and, although as large as his parent, was still being fed.*

Colour in a landscape is dictated by what we see, but as artists we are in a position to create and develop our own ideas. We may use the colours to influence ideas we already have – they may become stronger or paler, pinks may become purples, and yellows become green. We may decide to use complementary colours in order to turn our landscapes into something brighter or more mysterious. Just as certain aspects of landscape, such as long shadows during the evening, can add interest and direction, so can certain colours add mood and atmosphere.

When I found my subject for 'The Red House', I was attracted to the house across the field by the colour contrast of the yellow field full of buttercups and charlock, with the pink spiraea in the foreground and the deep red copper beech near the house. I painted the sky first followed by the pale yellow field and the pink spiraea. I then used masking fluid on the yellow field and pink spiraea before painting further detail.

Sometimes when painting, I deliberately base my colour idea on a particular feature in the landscape. For instance, a yellowish tree could influence colours in the rest of the painting, making some colours, such as purple, complementary to the yellow.

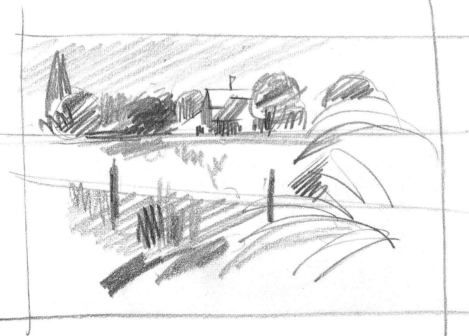

ABOVE *I drew a small pencil rough first before starting on the watercolour. The landscape appeared to be divided into three zones, with the foreground linking the three areas.*

BELOW *These dog roses were growing quite near the field where I was painting. They were very delicate and grew in profusion over the hedge.*

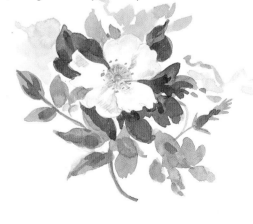

THE RED HOUSE
Size approx. 27 x 33cm (11 x 13in)
Painted on 300gsm (140lb) Bockingford paper

COLOURS USED:

COBALT

ULTRAMARINE

PRUSSIAN BLUE

BURNT SIENNA

BROWN MADDER

YELLOW OCHRE

GAMBOGE

A Day Out

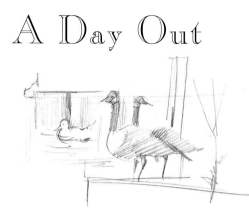

RIGHT *Although apparently a simple shape, it was tricky to get the lock house right. I noted my eye level and looked very hard at the shapes, but I actually had to alter the roof as I had made it too large. You will be able to see my correction – there is no erasing when ink is used.*

I am fortunate to live beside the river, and have spent quite a few painting sessions around Thames Lock in Weybridge. The lock house is very paintable, but this time I decided to make a detailed pen and ink drawing and afterwards to sketch figures in and around the lock with a view to making a more detailed painting later. There was quite a lot of activity, especially when a lively school party appeared (below). The geese and swans (opposite) could also be part of the painting I hope to complete later. I saw the swan further up-river, and it posed very nicely for me.

BELOW *I made these sketches in pencil and watercolour when a group of school children appeared at the lock, deciding to keep the figures very simple.*

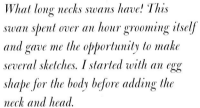

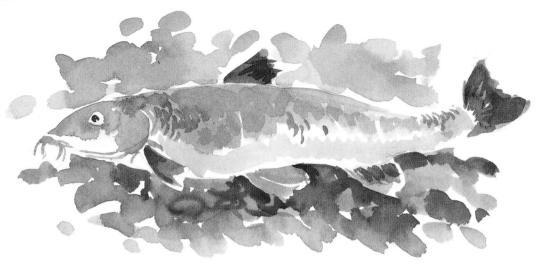

What long necks swans have! This swan spent over an hour grooming itself and gave me the opportunity to make several sketches. I started with an egg shape for the body before adding the neck and head.

ABOVE *I live in a place that is surrounded by water in the form of rivers and streams. In one stream the fish spawn on the gravelly bottom. They are quite easy to see in the shallow, fast-running water. This lovely fish is a barbel – lighter in colour than a chub, with pinkish fins.*

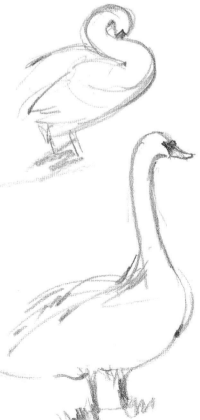

RIGHT *The river is a great attraction on a lovely summer's day and this lively scene attracted me. When painting water, I usually paint a base which is the same colour as the sky and then put in reflections, often wet-into-wet, using vertical strokes. I then overpaint when dry, adding reflections and surface movement on the water.*

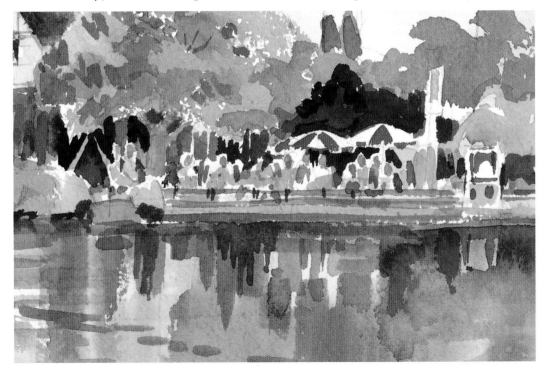

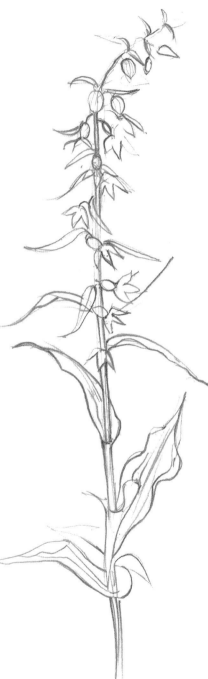

Wild Flowers

As summer draws to a close I take advantage of all the good days for painting outside! There is no substitute for painting nature as it is. Your senses are heightened and you are more aware of colours and textures than you can ever be in a studio. You will also become an amateur botanist and naturalist, and your knowledge of the living world will expand enormously.

Near my home is a large field which is cut for hay. When the hay is gathered in, it is pleasant to sit in the sun sketching and painting while the sweet scent of cut grass is still hanging in the air. The edges of the field are full of wild flowers and grasses, blackberries are beginning to form on the thorny brambles, and the hedgerows are full of life.

LEFT *A pencil study of a broad-leaved helleborine, a member of the orchid family. I took a particular interest in the shape of the flowers and the way the leaves seemed to spiral around the stem.*

RIGHT *These thistles were growing in waste ground on the side of a Welsh mountain amongst the slate, and were so handsome that I couldn't resist them. I used pencil and watercolour on a smooth cartridge paper, and would have liked to include the mountains, but time didn't allow.*

OPPOSITE **WILD FLOWERS**
I couldn't resist these handsome wild flowers – hog weed, yarrow, tansy and sorrel amongst different grasses, set against darker trees in the background. I used masking fluid to define the yarrow, hogweed and various light grasses and then washed in general areas of colour – yellow, pink, green and ochre – before adding any detail. The dark trees helped to throw the yarrow forward and to create a backdrop.

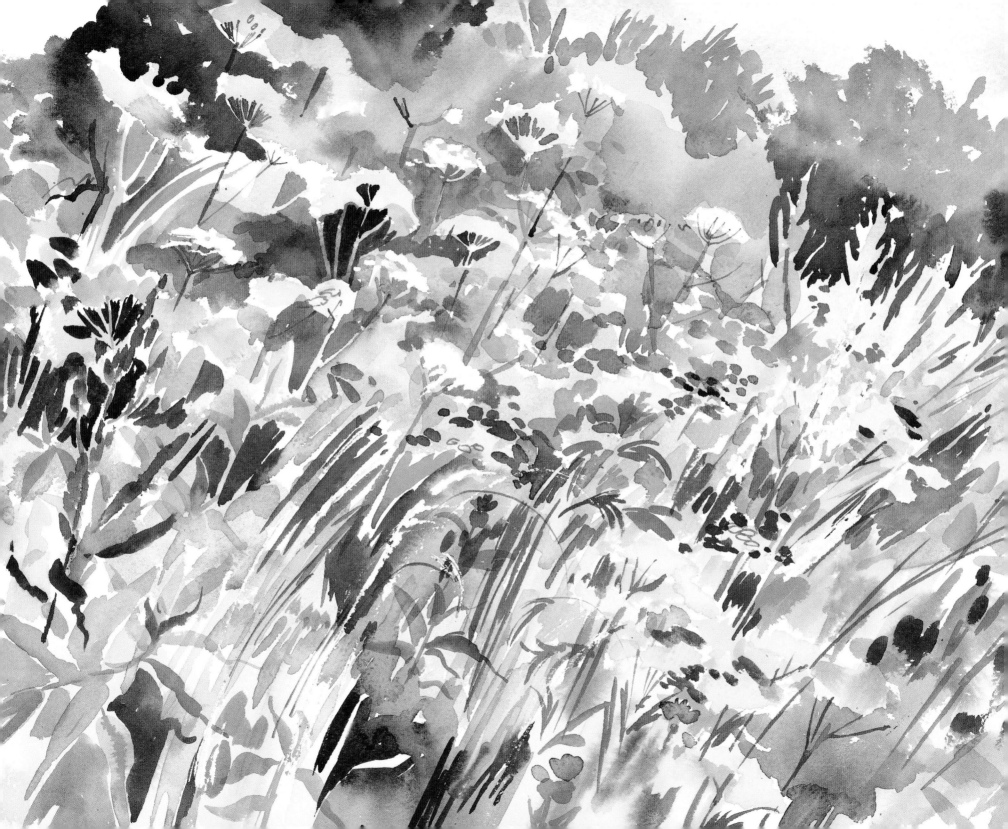

Late Summer

The apple trees are now laden with fruit, the tomatoes are beginning to ripen, and we have the blackberries to look forward to. The heavy rains and warm weather have given everything a new lease of life and the growth in the garden is hard to cope with. There are quite a number of young birds which appear to be fully grown but still follow their parents, demanding food.

The fox cubs are getting quite big now and the moles in my garden are active again. There are plenty of fishermen on the riverbanks and I hope they are not catching the lovely barbel that I have seen. Iridescent damsel flies, with banded wings, hover over the vegetation, darting streaks of light, turquoise and blue. On the darker side I found a hoard of slugs near the compost heap – not something I wanted to paint!

RIGHT *These gooseberries start ripening in early summer and go on for a couple of months. I enjoy making small studies such as this, as I find they help to keep me in practice.*

RIGHT *The tomatoes are doing well. I have several varieties ranging from small yellow ones to large red ones, but tomatoes, being (usually) shiny and red, are difficult as the shadow colour is hard to get right. To achieve this I use green, the complementary of red, as well as a darker red.*

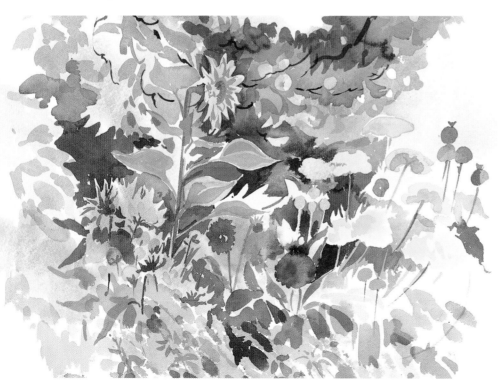

LEFT *These flowers were painted direct onto the paper (with no preliminary drawing) at the end of a sunny afternoon. I started with the sunflower and worked away from that, creating a vignette. There is still an amazing amount of greens to cope with, but I break them down to light, medium and dark and build up an impression of the garden, ending with the darker tones.*

THE APPLE TREE *This apple tree is quite old, but still bears apples that are sweet and delicious. To decide to paint an individual tree and make a considered study can be very rewarding. I concentrated on the main structure of the trunk and branches, and then worked broadly with washes, coming in to detail last. The light green was a mixture of Winsor yellow and ultramarine.*

AUTUMN

The early days of autumn can be very warm, and we all hope for an Indian summer to shorten our experience of winter. Days, however, begin to shorten and the nights are cool. Hazy sunny days give wonderful atmospheric effects, and the garden can often take on a fresh lease of life after rain.

Nature's Palette

When the first frosts come and the leaves start to fall, they change colour quite quickly. Autumn seems to go through different stages of revealing particular colours – first the yellows, then the oranges and reds, and later the browns, greys and blues. Colours at this time of year are so striking that it is often the season when people first start to think about wanting to learn to paint.

As I have been painting, I have been noting down the colours I use predominantly in autumn – they are alizarin crimson, brown madder, yellow ochre, ultramarine and cadmium yellow. There are other reds and browns to use as well, and it is worth trying them out to familiarize yourself with their qualities (that is, whether they are transparent or more opaque). Artists tend to have favourites and swear by certain purples or greys, and most would agree that practice is the best way of getting to know them.

Cadmium yellow

Yellow ochre

Brown madder

Alizarin crimson

Ultramarine

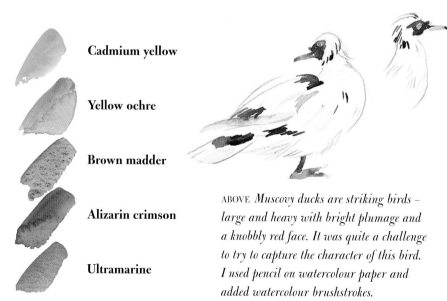

ABOVE *Muscovy ducks are striking birds – large and heavy with bright plumage and a knobbly red face. It was quite a challenge to try to capture the character of this bird. I used pencil on watercolour paper and added watercolour brushstrokes.*

LEFT AND BELOW *I am often surprised by the dark tone of the sky at certain times, especially when you compare it with a sunlit roof or a tree. Early evening, when the sun is low, is often a dramatic time for skies, particularly if the weather is changeable. It isn't easy to judge the right mix of pigment for a dark grey, and you have to be prepared for the wash to dry considerably lighter. Don't be afraid of using your paint and be generous with paper – if you don't succeed with your first attempt, try again and again.*

LEFT AND TOP RIGHT *Hazelnuts are not easy to find in autumn, as they mostly get eaten by squirrels in late summer, and birds love them too. The hazel is a favourite tree of mine, not only for its nuts, but also for the catkins in early spring when the tree is at its most beautiful. It has been in use through the centuries for hedging and for its tall branches or 'rods', which have many uses, from bean sticks to the making of boats and baskets.*

Harvest Time

Autumn is essentially a time for harvest. Apples are ready for gathering from early to mid-autumn and can be stored through the winter until almost Easter. There are still blackberries to pick, wonderful for jams and pies, and crab apples produce delicious jellies and wine. Apples can be used in so many ways – puréed, and in pies or chutneys, to name a couple.

Apples are a favourite subject of mine to paint, whether on the tree, arranged in a still life setting, spilling out of a paper bag, or simply placed on a table on their own. They make good starting subjects for beginners – their shapes are straightforward and colours simple, and they make ideal subjects for perfecting the wet-into-wet technique.

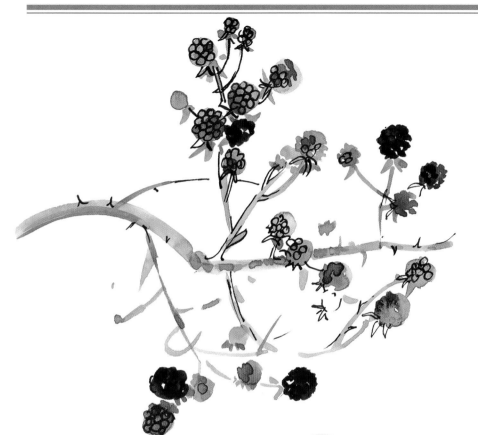

ABOVE *While I was painting these blackberries, which were in a tangle of brambles, I felt I should be picking rather than painting them. I used a No. 4 brush for the watercolour brushstrokes and then drew the detail with Indian ink and a dip pen.*

BELOW *Sometimes first impressions are best – they tend to have a boldness which captures the true essence of the subject. This sunflower was painted with a light tone of yellow followed by a darker tone of the same colour to make the shadow side. The brown centre further accentuated the light side of the flower.*

APPLES

This tree was laden with fruit and there were a great many leaves, so I selected my composition and drew the major apples and leaves before painting. I started with the apples, following on with the branches. I painted the leaves in one light tone before putting in the darker shadows. The grey background and other fruit were placed later. I used sap green, Winsor yellow, cadmium red, and burnt sienna.

Ricinus

The colours used in this painting of *Ricinus*, or castor-oil plant, seem to epitomize the colours of autumn. The plant comes from Africa and is often seen in formal bedding arrangements in parks. I grow it as an annual in my garden where its red leaves make a good foil for greens. The seed cases are also red and spiky. The deep red-green of the leaves, the red stems and fruits make it an interesting exercise, and also combine well with the yellow flowers of the curry plant.

I find that I have to work boldly when embarking on a painting of this kind. It was quite large – 38 x 56cm (15 x 22in). After drawing the main leaves and stalks, I mixed a pale yellow and, after dampening the paper, laid a wash over most of the picture area. I then dropped in brown madder on the fruits, and increased the yellow in certain places. I also used a pale green wash to hold the shapes of the yellow flowers.

Having established the design over the whole area, I started to paint in the *Ricinus* seed cases, followed by the leaves, stems and other details. I then looked for the darkest areas. The foliage around the plant was quite dense and complicated, and I indicated some of this by using various tones of green. I made a conscious effort to use complementary colours, and the background tree in a purple-grey complemented the yellow flowers. Another point worth noting is that the stems of the *Ricinus* add a structural note to an informal design.

COLOURS USED:

ALIZARIN CRIMSON	ULTRAMARINE
BROWN MADDER	PRUSSIAN BLUE
GAMBOGE	INDIGO
YELLOW OCHRE	

HIGHLIGHTED DETAILS:

1 Wet-into-wet.
2 Hard and soft edges.
3 Overlaid paint.
4 Negative shapes.
5 Direct drawing with a brush.
6 Sharp detail making a focal point using a light to dark accent.
7 Dark created by using saturated colour.

RIGHT **RICINUS**
Size: 38 x 56cm (15 x 22in)
Painted on Whatman NOT paper,
300 gms (140lb)

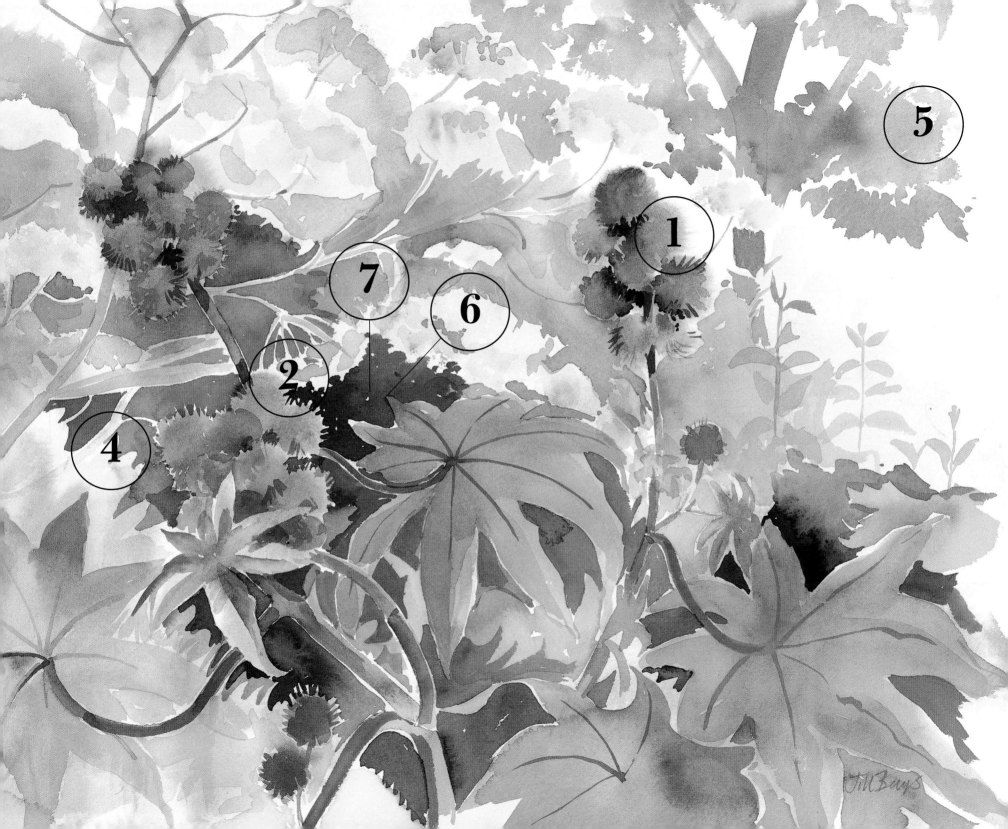

Brushstrokes

Free and lively painting is a challenge and it is often dictated by time. If you want to capture a changing scene you have to work fast to put down something that is only around for a short while, so you have to be reasonably accurate and practised in your methods. A part of this approach depends on the kind of brushstrokes you use. Using a brush can be as easy as using a pencil if you become accustomed to it. Forget about erasing mistakes – either wash them out or proceed, simply working over errors. I often plot out my composition with dots or dashes to indicate the position of certain important features.

Practise brushstrokes to get to know the capabilities of both hand and brush. Don't think that this kind of exercise is for beginners only – think how pianists always practise scales and warm up before playing a piece. Get used to using both your wrist and arm. If you sit, your strokes might be short and tight, but if you hold your work further away from you, or if you stand, you can achieve freer brushstrokes, using your whole arm.

BELOW *This cockerel and chicken were drawn with a charcoal pencil and a light watercolour wash to indicate the colour and feathers, making a vigorous and direct sketch.*

ABOVE *These alstroemeria keep flowering right up until October and are ideal flowers for practising brushstrokes as the petals are shaped like brushstrokes. For these I used my No. 12 brush as well as a finer one.*

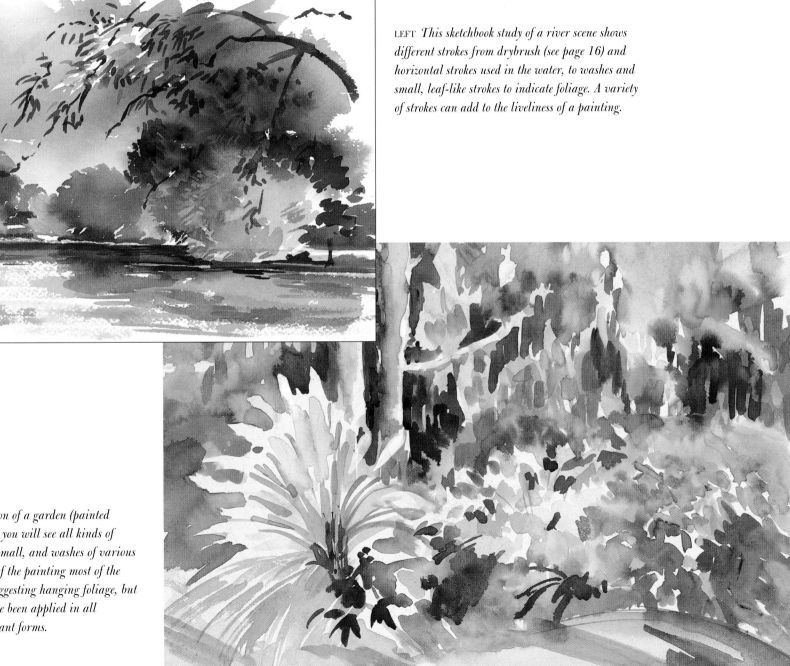

LEFT *This sketchbook study of a river scene shows different strokes from drybrush (see page 16) and horizontal strokes used in the water, to washes and small, leaf-like strokes to indicate foliage. A variety of strokes can add to the liveliness of a painting.*

RIGHT *In this impression of a garden (painted on an off-white paper) you will see all kinds of brushstrokes, large to small, and washes of various kinds. In the top half of the painting most of the strokes are vertical, suggesting hanging foliage, but many of the others have been applied in all directions to suggest plant forms.*

Flowers and Seeds

The flowering period of many plants can be prolonged by dead-heading them regularly but, of course, if you cut the flowers before they seed, you lose the opportunity to paint their highly decorative seed heads. Autumn is the best time for harvesting seeds and many seed heads provide ideal subjects for the artist. Plant forms have been used by artists throughout the ages as inspiration and decoration, and autumn is a particularly good season for studying their late flowers, leaves, and the many seeds and berries that make an appearance at this time of year. The jewel-like colours of turning leaves, and the knowledge that winter is just around the corner, gives us a sense of urgency and inspires us to paint a subject before it disappears for good.

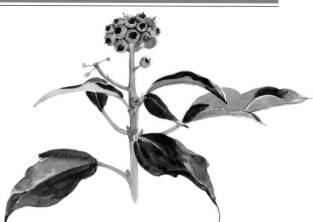

ABOVE *Ivy grows everywhere, on walls, fences and trees. The fruits are actually very decorative and eventually turn black, although birds eat plenty throughout the autumn and winter months. The leaves on non-flowering stems are easily recognizable by having five lobes, but here on a flowering stem they are plain. This was painted in watercolour on hot-pressed paper.*

LEFT *I find dried oats and corn useful in paintings, and they can be found in abundance in the fields at this time of year. This dried wild oat is particularly decorative – it grew from some seed that I had scattered on the lawn to feed the birds. (Occasionally I find wild sunflowers too!) If you are painting wild flowers, this sort of plant adds variety and height to a composition.*

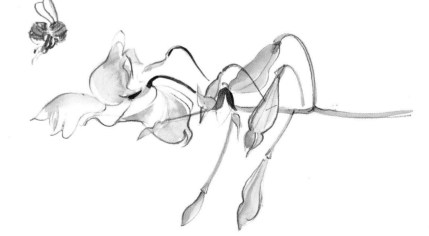

ABOVE *Indian balsam grows with great vigour in my garden – it is very invasive but, if kept under control, very beautiful with its lovely orchid-like flowers which are loved by bees. When the ripe seed heads are touched they explode in an alarming way and make you jump, and if you brush against them, they pop and crackle startlingly. I made this drawing in pencil with a little watercolour.*

BELOW *Poppy seed heads are often likened to pepper pots, as you can shake out the seeds. The head seen from above is a perfect design. I use the seed heads from poppies in my paintings in a variety of ways. The stems are straight, giving structure to unruly flower paintings, and the shapes are instantly recognizable as a background feature, or indeed in any part of a painting.*

ABOVE **GAZANIA**

The gazania originally came from South Africa – it is a good-tempered plant and blooms throughout the summer and into autumn quite happily. This painting started as an attempt to understand the structure of the flower; the background places the flower in a setting, and the use of a neutral grey sends the distant tree into the distance.

PAINTING FEATURE: Red Sunflowers

Flowers do not always grow in the setting that you want to paint them in, so to achieve the desired effect you may have to put together images from a variety of different situations. If you have kept a record of things you have seen and places you have been, you will have plenty of reference material to draw these from.

These sunflowers were late flowering and came into bloom in September – this was so unusual that I had to paint them, so I began without much thought about what was around them. They were very tall, and were growing in front of a willow tree. Having had a holiday in the Dordogne in France and seen sunflowers growing in profusion, I decided to put these sunflowers against a backdrop of rolling countryside such as I had seen in France and captured in my sketchbook. So my painting evolved, considering first the sunflowers, then the sky, the tree and finally, the landscape. To link the background with the flowers in the foreground, I used similar colours to those I had used for the tree on the left of the painting. When composing a picture from different elements it is important to make sure that the scale is correct and that the colour signature carries through the whole painting. The sketch of landscape I had made in France was also painted in September and therefore carried a similar autumnal feel.

COLOURS USED:

CADMIUM YELLOW

WINSOR YELLOW

YELLOW OCHRE

RAW UMBER

BURNT UMBER

SEPIA

LIGHT RED

BROWN MADDER

CERULEAN

PRUSSIAN BLUE

SUNFLOWER CENTRE
I used raw umber, burnt umber and sepia, followed by cadmium yellow dots, and some touches of gouache.

TREE
The colours in the tree were cerulean, yellow ochre, Winsor yellow and Prussian blue, used in a mixture of washes made with a No. 12 brush, plus separate brushstrokes made with a No. 7 brush.

SKY
The sky was a mixture of cerulean and a grey made with light red and cerulean, painted on a dampened background.

LEAF
This leaf was painted first with a pale green wash followed by a darker green, leaving the pale green to indicate veins.

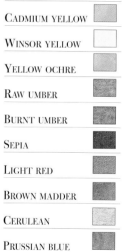

OPPOSITE
RED SUNFLOWERS
*Size approx. 38cm x 56cm (15 x 22in)
Painted on Arches NOT paper*

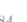

Gourds and Geese

The days can pass and we give little time or thought to the changing seasons until suddenly it seems that these changes cannot be ignored. Autumn comes with shortening days and cooler temperatures, changes which are gradual at first, but one day we notice the yellowing leaves on one tree and the red ones on another.

On a wet day in autumn, I started painting these gourds, and marvelled at their clear bright colours, and their simple (for the most part) shapes. I suppose I could call the painting opposite Harvest Festival – the gourds, beans, courgettes and tomatoes in it were all grown in my garden!

BELOW *When I looked at the gourds, I realized that several of them were very similar in colour, which created a difficulty as the tonal differences were so slight. I decided to make a tonal sketch while deciding how to tackle this, and came to the conclusion that the shadows had to play a part in resolving the problem.*

ABOVE *These geese were really noisy and appeared to be quite aggressive, however they were very amusing and made good 'guard-dogs'. I drew them in pencil, which I smudged with a finger to achieve a soft tone where required.*

RIGHT **GOURD STILL LIFE**

This still life was set up below eye level with a piece of painted paper as a backdrop, and with ivy to link the backdrop to the gourds. I drew the shapes in pencil and started painting with the lightest colours first – a variety of yellows and oranges were used, from lemon yellow to Indian yellow. The background was painted to resemble a fence in blues, greys and browns to complement the oranges and yellows.

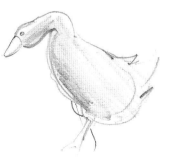

LEFT *These two gourds are almost identical in colour, but the shadow on the gourd behind helps to tell us that it is behind, while a slight change of colour on the gourd in front differentiates it from the other one.*

Autumn Leaves

The colours of autumn are incredible – deep reds, oranges, browns and yellows. The floor of a garden covered with maple leaves is a striking sight, and grasses glimmer and sparkle in late autumn sun, honesty shimmers in the first frosts, and plants take on a new beauty.

On dreary days, I enjoy painting still lifes, trying to capture the mood of the season by arranging things from nature that I have gathered in the garden or in the woods. The setting up and decision-making takes a while, as does stretching the paper, but all this is an important prelude to the enjoyable activity of painting. Ideas can develop throughout the painting – allow yourself to respond to the subject in front of you.

ABOVE *Virginia creeper leaves turn to brilliant red in the autumn.*

RIGHT *Horse chestnut leaves have rich colours and interesting shapes, and become fragile and tattered as they decay.*

BELOW *Rose-hips are loved by birds and these* Rosa rugosa *hips provide a great deal of winter food. They were painted directly with a brush in watercolour.*

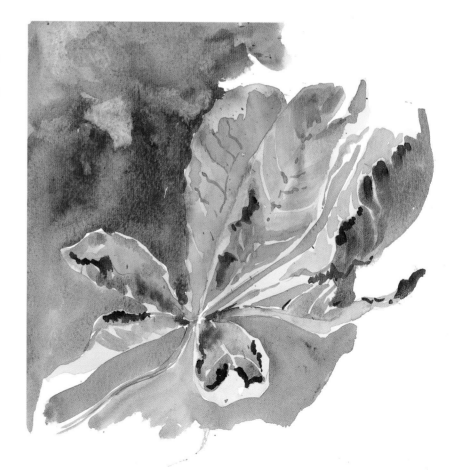

AUTUMN STILL LIFE

*A few flowers gathered before the first frosts, berries,
windfall apples, chrysanthemums in a small glass jar,
and some fallen leaves epitomized the colours of autumn.
I composed the elements of the still life on a sheet of white
paper then painted it directly with a brush without any
preliminary drawing. As I painted, I realized that the
shadows formed an important part of my composition.*

Countryside Sketches

It is a wise idea to keep your sketchbook in your pocket at all times and to note things which could be included in paintings. Occasionally I do leave my sketchbook at home and always regret it. However, when I am out and about in the countryside and have my sketchbook, there is always a subject worth noting at hand, from the atmospheric effects of changing weather, skies and shadows, to distant views and close-ups of flowers, trees and rocks. Don't overlook features such as gates and fencing as they can be especially useful elements to add to a composition. If you can't carry watercolours (brushes, palette and water), watercolour pencils and crayons can be useful substitutes to note colour and effects.

BELOW *The River Wey is an ever-changing scene. Before it branches off to become a canal, it winds gently around the fields, and there is a pleasant walk along the towpath where there are many painting opportunities. This small watercolour was based on a very slight pencil sketch with colour notes. The colour of the reflected tree intrigued me, but I am sure that if I had painted this on the spot the painting would have been quite different.*

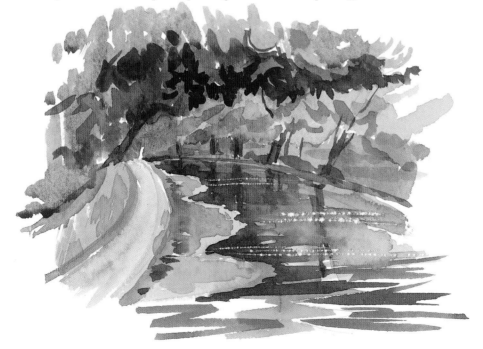

RIGHT *I picked up this old Scots pine cone on my walk in a country park. I drew it life-size in pen and sepia ink, getting a lot of pleasure from working in such detail.*

BELOW *This small watercolour landscape of the South Downs was based on a pencil sketch and a photograph. The warm foreground contrasts with the green, and the cloudy sky adds to the mood of changing weather.*

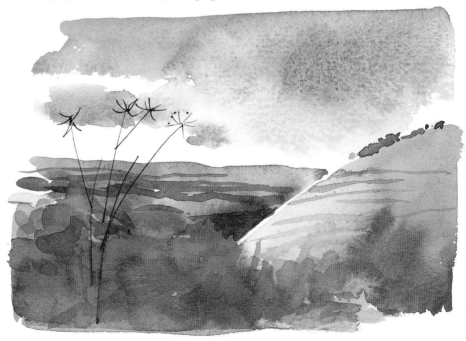

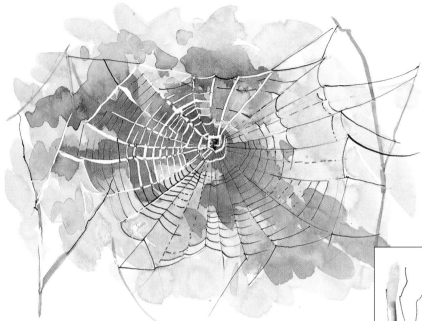

LEFT *How can one capture the delicacy of a spider's web? The strands are so fine that they are usually hard to see, but this one was beautifully highlighted by the dew. I drew it first in pencil, then applied masking fluid to certain areas, drawing over the remaining parts of the web in Indian ink (which is waterproof), which enabled me to make the washes behind. I looked in vain for the spider, but it was well hidden, no doubt waiting to pounce!*

Many different types of spiders live in and around my house and garden. The garden spider which spun this orb-web is one of many. In autumn, one can see the harvest spider with its very long legs – not to be confused with the daddy-long-legs, which also has long legs.

RIGHT *I made these sketches in my book while waiting for a wash to dry on a larger painting. All the subjects were within a few yards of where I stood, and although I may never use them, I'm sure that if I hadn't made them I would have found a need for them at some point! I keep references of all kinds, from books, cuttings, postcards, photographs and old paintings – all can be useful.*

91

PAINTING FEATURE: Walking in the Meadows

After heavy rains, the meadows near my house usually start to flood. Surrounded by rivers, this area is low-lying and there are some very boggy areas which quickly become lakes. Other parts seem to hold on to water, which in winter can freeze hard. I usually wear my Wellington boots, but even so, walking across the fields can be hazardous. As it is so flat and open, the winds are strong and the few trees always look wind-blown. As autumn moves into winter, it seems particularly cold and I am glad to get into the shelter of trees. I am always very conscious of the sky, and I look forward to the spring when it will be alive with the sound of skylarks.

I was pleased to get out of the house as the weather had been very stormy. I knew exactly where I was going, made a few sketches, then came home to paint. The sky was the dominant feature in this painting, filling the top two-thirds of the paper – dark against the light trees. I drew the skyline first, followed by trees and a rough guide to the placing of the rest.

The sky was painted mostly wet-into-wet, leaving a light burnt sienna area where the trees would be, followed by the suggestion of distant trees which would be strengthened later. I then proceeded to work down the paper, leaving white for the water. The furrows in the foreground were painted using green and ochre as a base, followed by various browns and a darker green, all rather wet-into-wet. The trees were painted next – first the trunk and branches, followed by an indication of the tops of the trees in ochre and burnt sienna. Finally I painted the reflections in the water, painted the fence and strengthened some of the washes.

COLOURS USED:

ULTRAMARINE		BURNT UMBER	
COBALT		RAW UMBER	
PRUSSIAN BLUE		YELLOW OCHRE	
BURNT SIENNA			

LEFT *In marshy places on the meadows, the common reed is a pleasant sight, and provides homes for warblers and other birds. These grasses are very tall and tough, and can grow to 3m (12ft) tall. In autumn and winter they seem to bleach out to a pale ochre.*

OPPOSITE **WALKING IN THE MEADOWS**
*Size approx. 25cm x 33cm (10 x 13in)
Painted on Fabriano rough 300 gsm (140lb)*

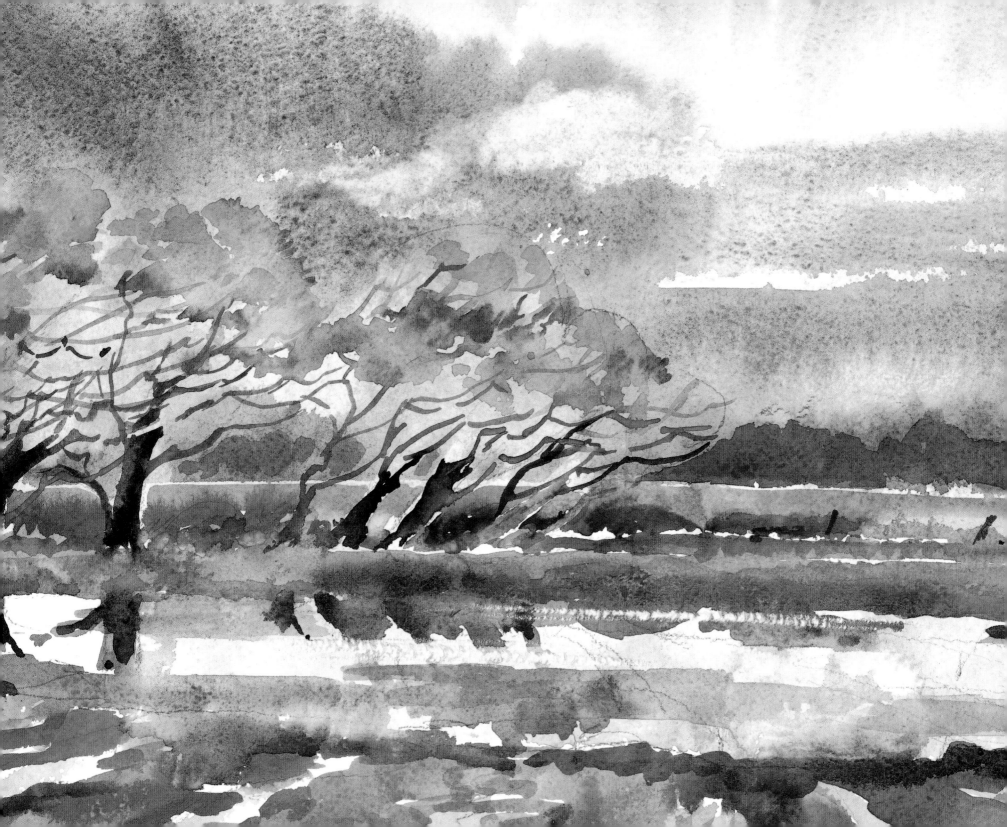

Late Autumn

When the last leaves are falling and there are just a few left hanging on the trees, you know that winter is approaching. The cat hardly goes out, and small creatures forage for as long as they can. The mellow feeling of early autumn has gone, and in its place come bleaker winds. When the first frosts arrive, deciduous foliage will disappear, leaving the tracery of the branches highlighted by the remaining colour of berberis and pampas grass.

A note from my diary: 'cold days, cold winds and the leaves fall fast, but there is a lot of colour left; the willows keep their leaves and the colour – light ochre – contrasts with the sky, which in this period of rain and sun produces not only indigo clouds, but rainbows. The effects are stunning.'

BELOW *Abandoned farm machinery, rusting away in the hedgerow, can make interesting subject matter. This sketch is a preparatory drawing for a painting yet to be realized. It required a lot of measuring and checking of angles to understand the structure.*

LEFT *The colour of the remaining leaves of a clematis that had climbed up into the apple tree was clear and bright. It was a challenge to achieve the dark background which was painted around the leaves and trunk.*

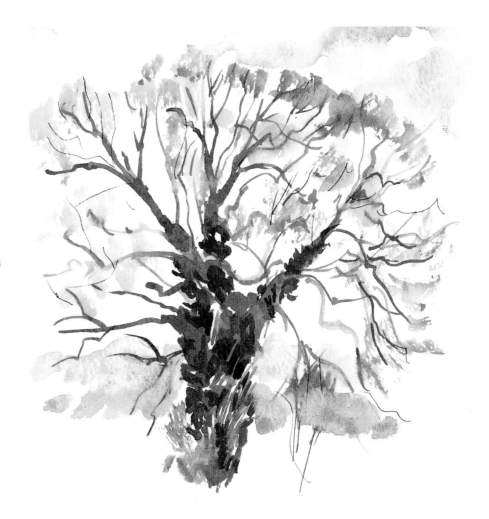

LEFT *The tree peony in my garden retains its attractive seed pods and leaves for a long time, right through to the end of autumn. Its flowers are short-lived, but the seed cases are very decorative subjects.*

ABOVE *I painted this tree from my window. It is a large willow with a great deal of ivy growing on it. I used a brush together with a small amount of pen lines for the small branches. The other branches were indicated with the drybrush technique.*

RIGHT *This poor little mouse was caught by the cat, then rescued and released by me, but not before I drew it quickly in pencil. A tricky subject!*

Autumn Days

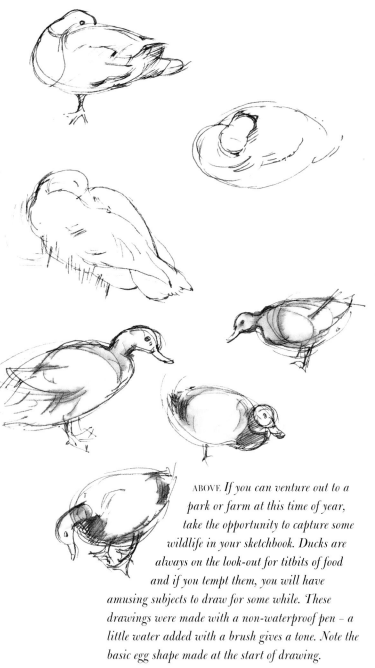

How beautiful the trees are at this time of year – yellows, ochres, russets, siennas and browns. Autumn vegetables are gorgeous colours, too, and there is a wealth of choice to be found in the greengrocer's when your own harvest is over. Onions, cabbages and broccoli make wonderful subjects, and there are a variety of unusual vegetables with brilliant reds and greens, or the deep, dark purple of aubergines. Often the simplest subjects can delight us as artists and make us think hard about composition, drawing, colour, and all the other components of painting, so that when the rain is falling and the days are cold and dull we can be busy with our painting.

BROCCOLI AND ONIONS
This small painting was drawn out in pencil. I started the painting with the onions in yellow ochre and burnt sienna, followed by the purple broccoli. The darker colours, the green leaves and shadows, were added next, and I finally added the darkest areas. Vegetables are rewarding as still life subjects – the colours are lovely and the shapes simple.

ABOVE. *If you can venture out to a park or farm at this time of year, take the opportunity to capture some wildlife in your sketchbook. Ducks are always on the look-out for titbits of food and if you tempt them, you will have amusing subjects to draw for some while. These drawings were made with a non-waterproof pen – a little water added with a brush gives a tone. Note the basic egg shape made at the start of drawing.*

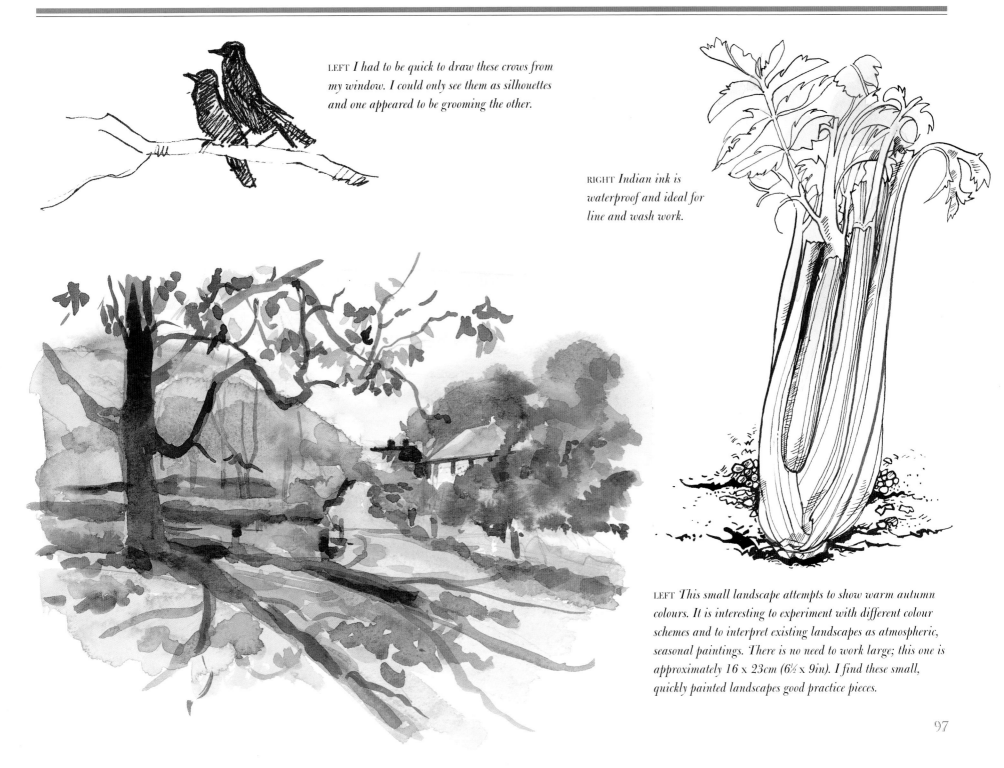

LEFT *I had to be quick to draw these crows from my window. I could only see them as silhouettes and one appeared to be grooming the other.*

RIGHT *Indian ink is waterproof and ideal for line and wash work.*

LEFT *This small landscape attempts to show warm autumn colours. It is interesting to experiment with different colour schemes and to interpret existing landscapes as atmospheric, seasonal paintings. There is no need to work large; this one is approximately 16 x 23cm (6½ x 9in). I find these small, quickly painted landscapes good practice pieces.*

Changing Seasons

Who is to know when autumn ceases and winter begins? It is a windy day and the leaves are falling to the ground like confetti. The wind drops and they lie motionless until a gust picks them up again and blows them hither and thither. Like the leaves, the seagulls whirl and flutter in the wind. They move so fast, one can get only an impression of them. On a cold day, I had thrown out bread on the grass which they spotted with their sharp eyes and quickly swooped down to pick it up on the wing. These seagulls were almost impossible to draw. I made various attempts and used a soft pencil to start with, finishing and strengthening the lines indoors later.

BELOW *This brief sketch is of a group of ring-necked parakeets which are rapidly colonizing the area where I live. They are striking, bright green birds. I was spellbound when they visited the nuts hanging from a small tree. In summer they rob the fruit trees, and in spring they peck the almond blossom. They never land on the ground, and fly in small flocks of five to ten birds.*

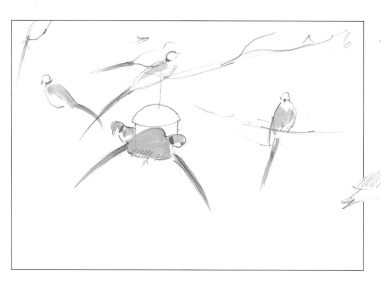

ABOVE *Right at the end of the season, I cleared out the birdbox on the silver birch tree. Its summer visitors, a great-tit family, had long since departed. Sometimes birdboxes can be useful homes for small birds in the late autumn and winter months.*

AUTUMN LEAVES

The late autumn leaves are brown and starting to decay as winter arrives. In painting them, I used all the earth colours – burnt umber, burnt sienna, yellow ochre and sepia, with a little cadmium red and cadmium orange, and ultramarine for the shadows. What a chance to get to know your palette! Arrange leaves on a sheet of paper and draw the shapes in pencil before laying washes – apply the lightest colours first. Then build up your darks, and add the details last.

WINTER

Winter is a time for reflection, for remembering lovely summer days and for dreaming about the coming year. Little is happening in the garden through the season but in January, gardeners are already preparing to plant seeds and ordering plants for the spring.

For watercolourists, winter is a good time for brushing up on drawing skills and setting up still-life subjects in the warmth and comfort of the studio. Winter is also the time to get your materials in order, to practise using colour, to really get to know your colour mixtures (especially those difficult greens), and to experiment. You can use daylight bulbs, spotlights and candles for stunning lighting effects. For intrepid landscape painters, there are hand warmers, hot water bottles and flasks of hot coffee to make the cold more bearable. Falls of snow always make me want to get out with my paints, even if the paint water does freeze.

Nature's Palette

Winter colours are often sombre but rich earth colours such as siennas, umbers and ochres can be interesting and combine well with subtle greys and blues to make exciting and harmonious colour arrangements. The stark contrast of white snow and dark trees with the subtle shadow colours that are seen on snowy days make every artist long to paint them.

Cerulean

Grey mixed from ultramarine and burnt sienna

Yellow ochre

Burnt sienna

Burnt umber

BELOW *Drawing this lonely, nearly dead, windswept tree in Wales, I wondered how many years it had been bending in the fierce north-west wind. It made a dramatic silhouette against the sky, and I drew it using Indian ink with a pen and brush, diluting the ink where necessary.*

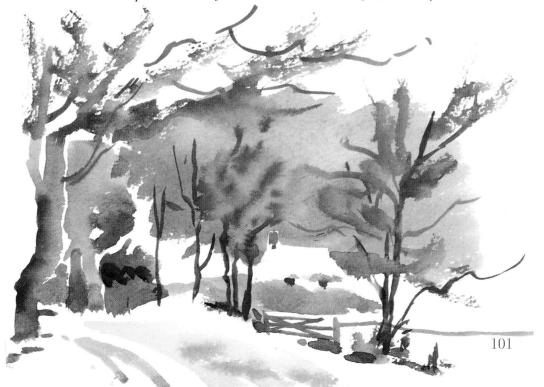

BELOW *These crows are nearly always in my garden in winter, looking for worms or just looking about. They are very observant and seem to watch me, but are shy about taking the food I put out for the small birds near the house.*

BELOW *This small winter sketch is the essence of brevity and it uses the colours of the winter palette. A lowering sky which defines the snow-covered roof, with the addition of some ochre and sienna detail, is as much as one would want to paint on a cold afternoon.*

ABOVE *These noisy rooks roost in a group of Scots pines. They seem to fly quite a distance to feed, but always return at dusk.*

ABOVE *Winter skies can be very dramatic, particularly at sunset when you might see violets and oranges of every shade. These three sky studies all have a base wash or tint of either raw sienna or burnt sienna, which was allowed to dry completely before using further washes of greys, blues and pink.*

101

Woodland in Winter

In the woods, the dead leaves crackle underfoot but the trees still provide some shelter from the wind and deflect the rain. The undergrowth has died back, and the branches of the trees are silhouetted against the sky – all is light and airy. Wild creatures seek refuge in the woods. On a favourite walk of mine I have seen deer and wonder if they are escapees or wild. In some parks it is often possible to get quite close to deer, and if you use a camera with a long lens you could work from a photograph of them. Looking for deer tracks in mud or snow can be interesting and will eventually lead you to them.

If you do work from photographs, remember that it is not easy to achieve a fresh and lively drawing. Although working from life is tricky, you will achieve a freer and more spontaneous result. Just remember that to do this you have to look hard at the subject and really draw what you see – not what you think you see.

ABOVE AND RIGHT *I painted these deer partly from observation, and also used books and photographs for reference. I used a pencil to capture their forms and then added light washes of colour.*

BELOW *On the woodland floor you can find all kinds of leaves, fir cones, sweet chestnut cases and, on the edges of woodland, berries of various kinds, rose-hips and brambles. Dried cow parsley, teasels and grasses also make decorative subjects. I drew these fallen leaves with pen and ink.*

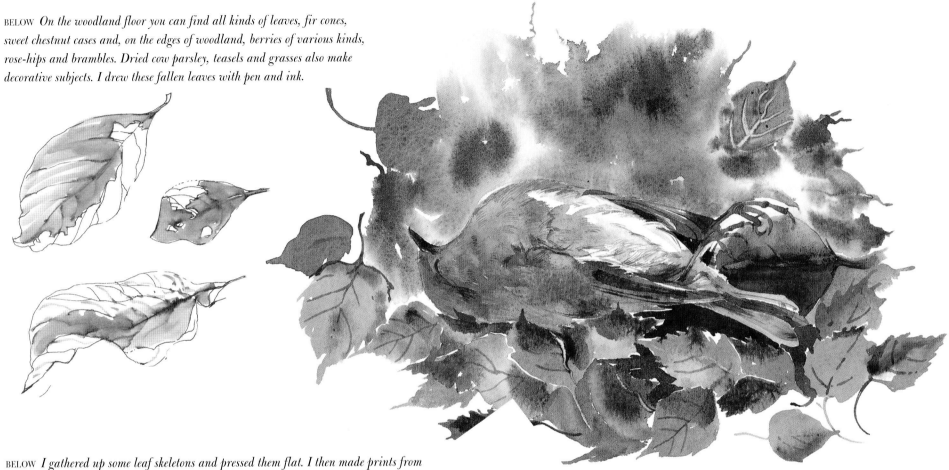

BELOW *I gathered up some leaf skeletons and pressed them flat. I then made prints from them using watercolour paint, adding some detail to the leaf veins with pen and ink.*

ABOVE *I found this poor little robin which had just died. I put the bird on a bed of leaves and grasses before painting it. I had previously tried painting a stuffed robin, but it never looked right, so this was a good opportunity for some direct observation.*

103

Frosts and Fine Days

Occasionally in early winter there are quite severe frosts, a foretaste of conditions to come. Familiar landscapes can change quite dramatically in mists and coatings of ice, and sunlight can enhance the magic of the frost before melting it. There will still be days that provide opportunities to paint outside so sometimes you have to seize the moment as I did when I painted the river scene opposite on a clear, cold day.

BELOW *The skeletons of plants take on a peculiar beauty in a frost, and often the colour is enhanced. The low sunshine in winter can pick out plants which go unnoticed at other times of year. I made this painting from reference and imagination, using a palette which contained purple madder and yellow ochre, which are complementary colours. I used the wet-into-wet technique and also quite a lot of washing out.*

LEFT AND BOTTOM
Magpies and jays are frequent visitors to my garden – the jay is very wary and difficult to draw as it flies away as soon as it sees me.

ABOVE *Fly agaric is a brilliantly coloured, extremely poisonous fungus which can be found in birch woods in late autumn and early winter. Although an attractively coloured toadstool, pick and handle it with care, using disposable gloves.*

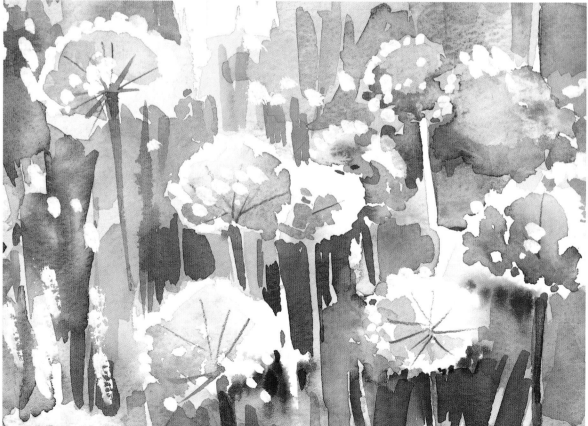

DREDGING THE RIVER

Dredging had been going on for some time up and down the river close to my home. It was quite a bright scene with the flags and the boats. As it was so cold, I painted the sky first at home, then went out and drew the boats and trees. One of the boats had moved, but as I had already sketched it I didn't need to change it. I painted quickly using a fairly limited palette – ultramarine, burnt sienna, yellow ochre, burnt umber, and cadmium red for the flag. Reflections were fairly still and quite a few brushstrokes are prominent, including those of the flat brush which was used for the water. I used gouache to paint the boat fenders. The dredging boats had disappeared the following day, so I was pleased to have captured the scene.

A Winter Walk

One of my favourite walks in winter is over an ancient common and heath where there are some silver birch trees, heathers and grasses (in summer there is also cotton grass and bracken). To arrive there I walk through a conifer wood – all fir cones and needles, pebbles and sand – then through a deciduous wood with chestnuts and beeches, and on to a small lake with large rhododendrons growing around it, before coming out on to the heath. I often see squirrels – if I am lucky I might see a deer or hear the laughing call of a woodpecker. In autumn, there are many sweet chestnuts to be gathered, and in winter the colours turn to silver and grey, with browns and ochres. It is a popular place for horse riders and dog walkers.

BELOW *Middle distance trees need a little practice to paint. I have used a dry-brush technique here which required a light touch. I often use a flat brush for this effect, and tend to keep my colours pale.*

RIGHT AND BELOW *After a walk, dogs love to relax, and this is a good time to draw them. After some fidgeting this dog finally fell asleep and I made some sketches with a 2B pencil.*

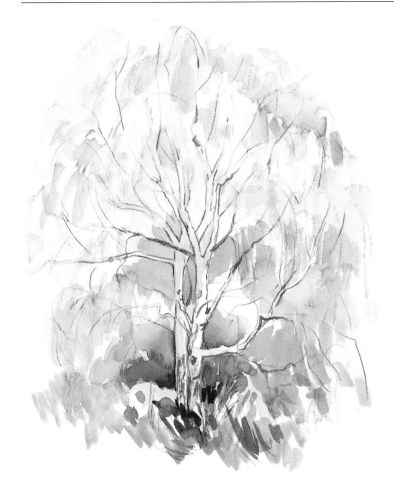

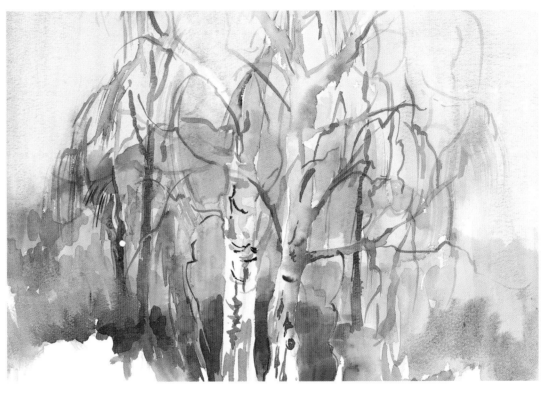

ABOVE AND LEFT *These two paintings of trees show a progression in my approach to capturing a scene; the first (on the left) is a straightforward observation in pencil and watercolour, the second (right) is a watercolour based on the first. Experimenting like this can help you improve your powers of observation and also to use your creative imagination. Use your study to help you to be really creative in your use of colour. Why not try working on tinted paper and using gouache for your whites? I find that standing up to work, rather than sitting, does encourage me to be more creative and certainly freer in my approach.*

LEFT AND RIGHT *Twigs and small branches can be drawn with a variety of media – a brush, a conté pencil, a lead pencil or a pen. Use a fine brush, or a rigger brush (which has extra-long hairs).*

107

Birds in Winter

ABOVE *The tawny owl is about 38cm (15in) long, and is distinctively marked in shades of brown. It did not appear to be shy, quite unlike the barn owl which hid and hissed at me. I had to work quickly and used my No. 12 brush which has a good point (useful for detail).*

RIGHT *These little owls were very shy, except Oscar (on the left), who was obviously rather annoyed! These birds are only about 22cm (9in) tall.*

I am more aware of birds in winter than at any other time, perhaps because I feed them daily – nuts for the blue tits and great tits, and bread and seeds for other birds. The lack of leaves on the trees makes the birds more visible, and their activity during the daylight hours makes me aware of how short the days are now.

At one time, an owl was often quite visible in the large tree at the bottom of my garden – he would hoot quietly and I definitely had the feeling that I was being watched! But I have never seen an owl close-up, apart from in photographs, so I was very fortunate in being able to sketch these owls at an aviary. They watched me in a very solemn way, giving me plenty of opportunity to sketch them, except for the barn owl which was very shy. When sketching these owls I was reminded of the marvellous drawings and paintings of wildlife artists, and realized how much study from photographs and observation is necessary to be successful.

LEFT *A heron's skull – a rare find! I have seen a dead heron and was amazed at the span of the wings, I was equally surprised when I saw the length of the beak here – how dagger-like and efficient for catching small fish!*

BELOW *These two small sketches were all I could manage, as this barn owl was extremely shy and mostly hid from me when he thought I was looking at him. His face was particularly distinctive, but I was too far away to achieve any detail.*

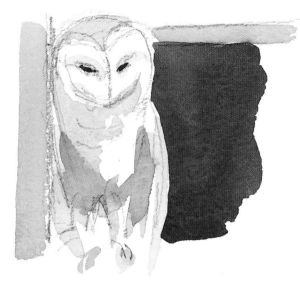

SNOWY OWL

The snowy owl is quite rare and mostly a winter visitor to Scotland. Larger than a barn owl, it is white except for markings on the wings and back. When making quick watercolour sketches, you have to go for the essence of the subject – in this case it was the yellow eyes and penetrating gaze.

109

PAINTING FEATURE: An Exotic Flower

During the winter when it is cold, it can sometimes be difficult to get hold of indigenous natural subject matter to paint – so why not try something exotic? I have always been fascinated by Strelitzia, the plant that has a flower which looks like a bird. In fact, this striking plant from Africa is also known as the bird of paradise. I saw it growing last year in a greenhouse, and made a few sketches and took some photographs which gave me ideas for a painting. This year I managed to get a Strelitzia from a florist, so I was able to start the work I had in mind. It is always better to see the plant growing as it is difficult to imagine the size and how it grows. Whilst in the florist, I saw other exotic flowers which have given me more ideas for colourful subjects.

Using my sketches and photographs, I made some small 'idea' drawings and decided to use the one shown on this page. I then made a study of the living flower to ascertain colours, and tried out various ones to get the right orange for the petals.

I decided to start a larger painting and drew it fairly carefully using both the live flower and the photographs as reference. I then added some of the plants in my conservatory to the composition, indicating them more loosely. Painting started with the lightest colours, and I tried to cover the white paper fairly quickly to get an overall feeling of the painting. I don't follow any rigid procedure when painting as one thing can influence another, but I certainly try to reserve my detail until last and then increase the darks, which seems to pull the whole thing together.

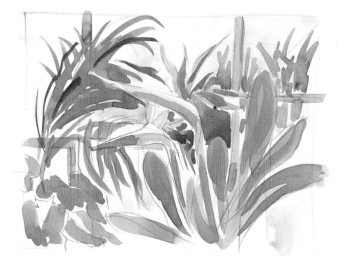

LEFT *This was one of several idea sketches and the one that I finally chose for the composition.*

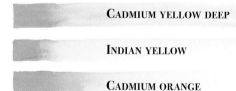

CADMIUM YELLOW DEEP

INDIAN YELLOW

CADMIUM ORANGE

COLOURS USED:

CADMIUM ORANGE		CERULEAN	
CADMIUM RED		BURNT SIENNA	
ULTRAMARINE		PRUSSIAN BLUE	
BROWN MADDER		SAP GREEN	

LEFT *To get to know the unusual shapes of the flower and leaf, and which colours to use, I made a fairly detailed painting on Bockingford paper at the size I intended to work for the finished painting.*

An exotic flower: Strelitzia
Size approx. 38 x 56cm (15 x 22in)
Painted on Arches NOT paper, 300 gsm (140lb)

Painting in Mid-winter

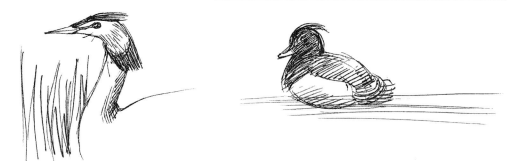

After the flurry of Christmas, I like to settle down again to painting and sketching, sometimes venturing out into the cold, but preferring to work indoors. I have a willing model in the form of my cat as she tends to sleep a great deal at this time of year, so I have every opportunity to sketch her. I also like to paint the selection of interesting fir cones, pebbles and feathers (see below) that I collect through the year.

Out in the fields, horses and cattle are being fed on hay so they tend to stand still for quite long periods rather than constantly moving as they graze. And at this time of year, watching the bird life on sheltered lakes and rivers can be rewarding as you often see birds that are more secretive at other times of the year. I don't often see tufted ducks, but the great-crested grebe (above right) is quite frequently visible on the river.

BELOW *I drew these feathers at actual size on cartridge paper in a variety of media – pencil, coloured pencil and pen.*

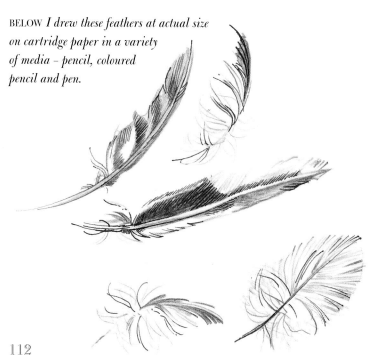

BELOW **SILVER BIRCHES IN THE SNOW**
I painted this from my window, and was able to capture the fresh fall of snow still on the branches of the trees. I painted in a very direct manner, with no pencil drawing at all, using the white paper to represent the snow. I often think of calligraphy when painting snow scenes as the brush can be just as expressive as a pen.

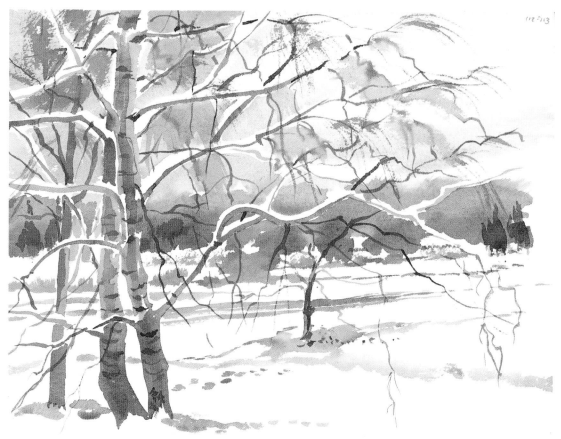

BELOW *When drawing animals, it is important to look for general shapes and directions, and the spaces between the legs. Try to get the head in proportion to the body, measuring and checking all the time. Use sweeping lines as I have in these sketches of horses, and try not to be too tentative.*

ABOVE AND BELOW *I drew my cat Sophie with a very soft 6B pencil (below) which I smudged with my finger to indicate her colour as she is an all-over grey cat. In the larger drawing (above) I added some watercolour. Note the shapes, which are really quite basic ovals and circles, to which I have added the ears, tail, paws and the head.*

Winter Interpretations

As an artist, you have to be observant, aware and receptive to everything around you. Sometimes you have to be constantly on the lookout for an opportunity, while at other times a subject will present itself to you out of the blue. In the middle of winter, I found some dried seed and flower heads – an allium, an acanthus and a cardoon – in my garden shed where I had put them for safe keeping and then forgotten them! Although their colours were bleached out they still possesed their original beauty and presented me with some marvellous subjects to explore.

After I had made the pen and ink drawing of the cardoon, I was so intrigued by the subject that I decided to try a different interpretation of it using watercolour and resist techniques. I used masking fluid to mark out the fine lines and then applied candle wax to achieve a textured background. I painted the cardoon lightly in watercolour, adding detail with a dip pen and Indian ink. The colours used were earth colours – siennas and ochres. Don't be afraid of mixing media if you feel that the subject requires it.

LEFT *This allium seed head was painted with a fine brush.*

RIGHT *The cardoon is a majestic and stately plant that grows in my garden. I have painted it in the summer when the flower is a beautiful purple and it towers above my head, reaching over two metres (seven foot). The spiky character of the magnificent dried flower head calls for pen and ink, and I chose sepia ink.*

RIGHT *This is a loose interpretation of a cardoon. The seeds appeared to 'fly off', and the soft, thistledown appearance and spiky surround were intriguing enough to make me try out several differnent ways of painting this seed head.*

Acanthus

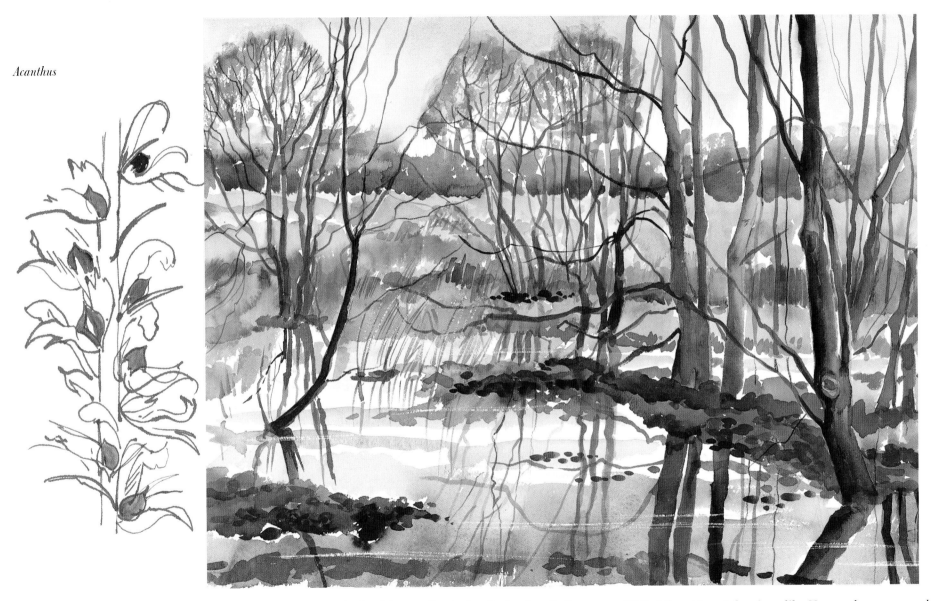

ABOVE *After heavy winter rain, low-lying woodlands often flood – the reflections are so still that they appear to be mirror-like. Many rushes, grasses and sedge grow here, and ducks find a sheltered home amongst the trees. Note how the tree trunks are often green or grey green – hardly ever brown. In a scene like this you can use all the earth colours. Although there is no 'apparent' composition here, the light water leads the eye into the picture, and the trees not only frame the distance but act as a kind of grid over the picture area. I look forward to the spring, when the ditches will be full of wild irises.*

PAINTING FEATURE:
The River in Winter

On a bright frosty day in December I made a decision to get out and paint. I had already picked my subject and intended to paint it from the car as it was really quite cold. As time was limited and it was so cold, I had to work fast – I knew the subject well and was able to begin drawing without delay. I settled on a central point and worked out from there.

I drew in the main areas and quickly started painting, as I knew that everything would take a long time to dry. The sky was blue, and colours seemed heightened in the sunshine – ochres, russets and greens stood out well. The water was hardly disturbed, making the reflections clear. Unusually, I left the sky, as I knew it would take too long to dry, and concentrated on the distant trees and bungalows and then their reflections. The nearer trees and their reflections were painted next. I painted the sky at home, where it was warm and dry.

COLOURS USED:

ULTRAMARINE		BURNT SIENNA	
COBALT		PRUSSIAN BLUE	
YELLOW OCHRE		INDIGO	
CADMIUM YELLOW			

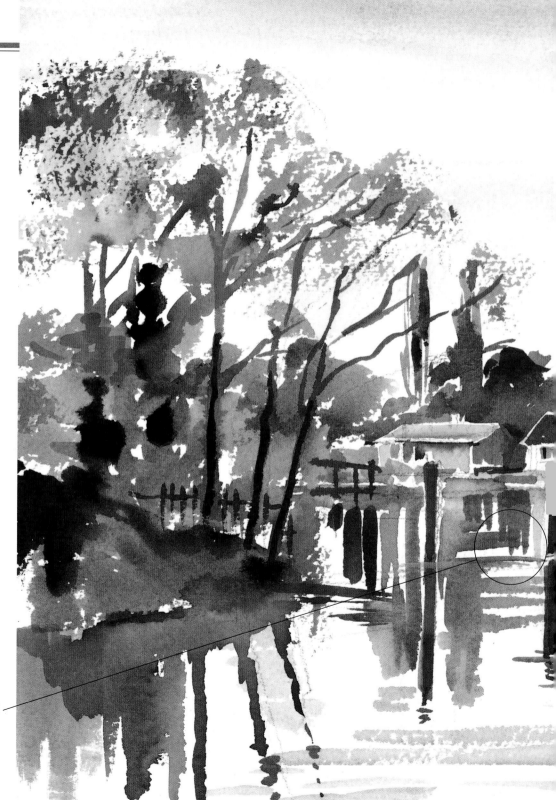

Vertical strokes for reflections and horizonal strokes for movement.

The sky was a straightforward gradated wash.

When working quickly, leave a small paper 'dam' between washes, unless of course you are working wet-into-wet.

Pure yellow ochre and burnt sienna were used for the trees in the background, and colours were kept as pure as possible.

Reflections

As I live near water, a great deal of my time is spent looking at it and I have developed certain strategies for coping with reflections. I use vertical strokes for the reflections and horizontal strokes for the movement on the water. Remember that the shape of reflections will change according to the movement of the water, and you can add life to your painting of water by including surface movement, such as the ripples thrown out by a boat or ducks, or simply by a stone or stick thrown into the water. The movement of water can take various forms, from the smooth, oily reflections in a harbour to the dancing ripples observed further away.

Note the drybrush strokes in the foreground and in the trees on the left.

THE RIVER IN WINTER
Size 36 x 26cm (14 x 10in)
Painted on Arches rough, 300 gsm (140lb)

Jill Bays

Snow

Snow doesn't seem to fall here very often, so that when it does arrive I immediately reach for my paints. There are many lovely impressionist paintings of snow to be inspired by – but inspiration is one thing, and practicalities another. An alternative to being very cold is to paint from a car, but remember to take a hot-water bottle.

Painting landscapes in snow can be a linear and almost calligraphic exercise. You are virtually working in reverse – where normally you would use colour, you leave your paper white. Shadows on a sunny day can be blue on snow, but without sunlight they do not appear at all, and the snow can take on a yellowy tinge.

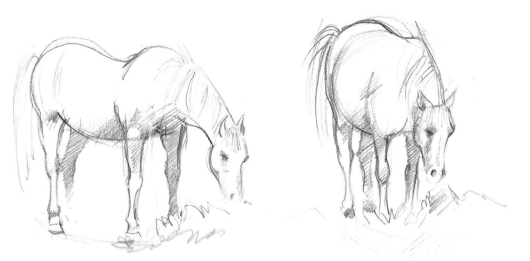

ABOVE *Horses feeding in cold weather when the ground is hard and there isn't much food available always look a little sad, but at least they stand still. Note the curving rounded shapes used in these sketches.*

BELOW *These starlings really enjoyed the rotten apples I had thrown out, so I took the opportunity to capture them in my sketchbook and was able to use this sketch in the painting opposite.*

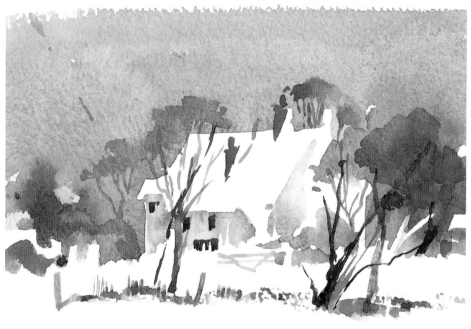

STARLINGS IN THE SNOW

This is a composite painting, made partly from sketches (see opposite) and partly from imagination. I used an old watercolour painting as a guide to the subject as well as the two sketches shown here. I adapted the farmhouse and added fir trees. The white paper is the dominant theme and I used ultramarine, brown madder, yellow ochre and sepia, with a touch of cadmium red for the apples. I have painted this farmhouse many times. It has a slightly romantic air about it, and is well away from the road and slightly hidden.

Winter Landscape Ideas

It can be difficult for us artists to get motivated in the winter. The idea of standing around sketching landscapes in the cold isn't immediately appealing and subjects often have to be brought in to the warmth of the house. Here pencil sketches can be finished off and note-taking embellished. Also paintings can be improved and ideas worked on, you can perfect techniques and improve your drawing. I often work on sketches in the studio and find it a good time to experiment with colour and composition.

Working in the studio can provide the time to study landscape compositions and consider why one idea works and another does not. Raising or lowering the eye level can give a dull idea a new look. Experimenting with atmospheric ideas also helps – the sharp contrasts of a sunny day, or the effects of mist, can dramatically change a landscape painting.

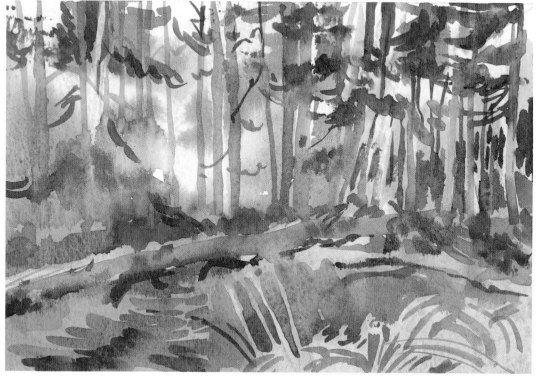

RIGHT *Until I actually drew Scots pine needles (near right), I hadn't realized how long and sharp they are, and they gave a wonderful opportunity to practise those brushstrokes. In contrast, the smaller fir-tree needles (far right) are short, and the branch shown here had a definite back and front. Making detailed studies such as these can give you an understanding of how and why things are structured the way they are. The Scots pine with its long loose needles is perhaps more suited to high winds, while the fir can shed snow easily.*

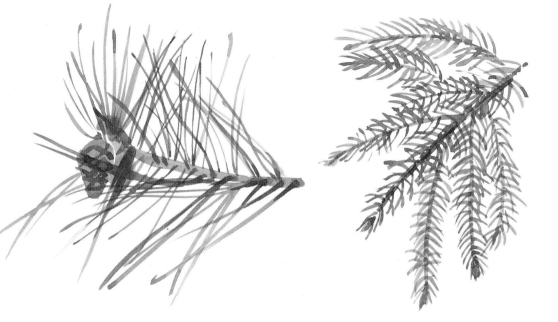

ABOVE **WOODLAND**
This small landscape was painted partly from sketches made in a Sussex wood, and partly from the imagination. Initially I had an idea of painting a misty morning, but wet-in-wet is rather a hit and miss affair, and I liked the red and green colour scheme, so decided to leave it as it turned out.

120

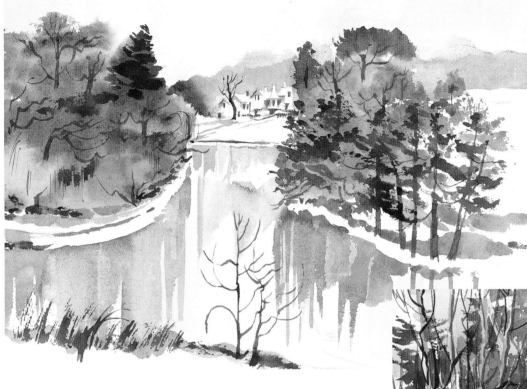

LEFT **THE RIVER ON A SNOWY DAY**

I painted this from a bridge, hence the unusual eye level. The composition was based on interlocking curves, and the reflections were long and vertical. The cool colours of the landscape highlighted the warmer colouring of the trees.

BELOW **THE WEIR STREAM**

This painting reminds me how a landscape can be affected by the weather – the water is usually much calmer than this. It can be quite exciting to paint on a bright and windy day as long as you are sheltered. Note the spray and small branches which were scratched into the paper with a sharp knife right at the end of the painting.

BELOW *These cows had been feeding on hay and were walking through a field when they suddenly saw me! It was a surprise encounter. They quickly moved off and this was all I had time to do.*

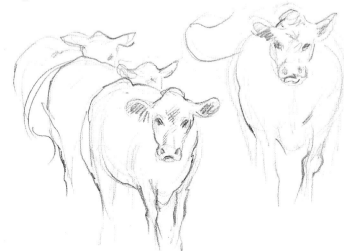

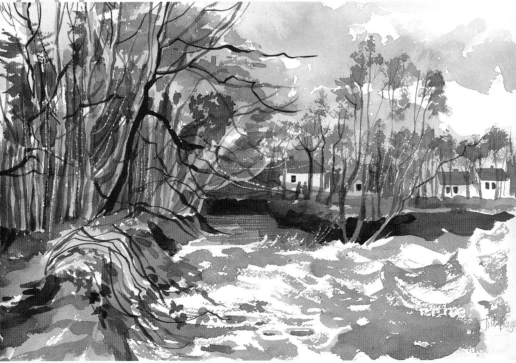

121

Vegetables

Warming casseroles of leeks, mushrooms, potatoes and cabbage are welcome during the cold days of winter. But before the vegetables go in the pot, make some studies of them – they can have a charm all of their own! Turnips and swedes have the potential to be a watercolourist's delight – such simple shapes and lovely colours. Turnips are cream to violet and green, swedes are apricot and purple – ideal opportunities to practise your wet-into-wet techniques!

Don't forget that artists often have to enhance their subjects with an extra dimension to make the onlooker more aware of colours, shapes and form. Sometimes it is enough to strengthen the dark areas to highlight light areas, or maybe to take advantage of the colours in your palette by making your colours sharper or stronger. Drawing can be improved upon in subtle ways by exaggerating shapes.

ABOVE *One is always more conscious of the sunsets in winter because the days are so short. I am lucky to have large windows that I can paint from. Some days the light levels are very low which means working with a daylight bulb and you are hardly conscious of the sunset at all, but on a bright day they can be spectacular. Colours can be strong and bright, and contrast with the landscape which is often dark. Yellows, reds, oranges, purples and greys are all colours seen as the sun goes down.*

BELOW *Mushrooms are such lovely shapes and colours – sienna, umber, grey, ochre – you can use all your earth colours to paint them. I sometimes prefer to look down on a subject as the high eye level can give more enjoyment of the subject.*

RIGHT *A line and wash drawing of leeks – the underlying pencil drawing is quite strong and the wash is roughly laid. You could use a pen line or charcoal to draw with instead.*

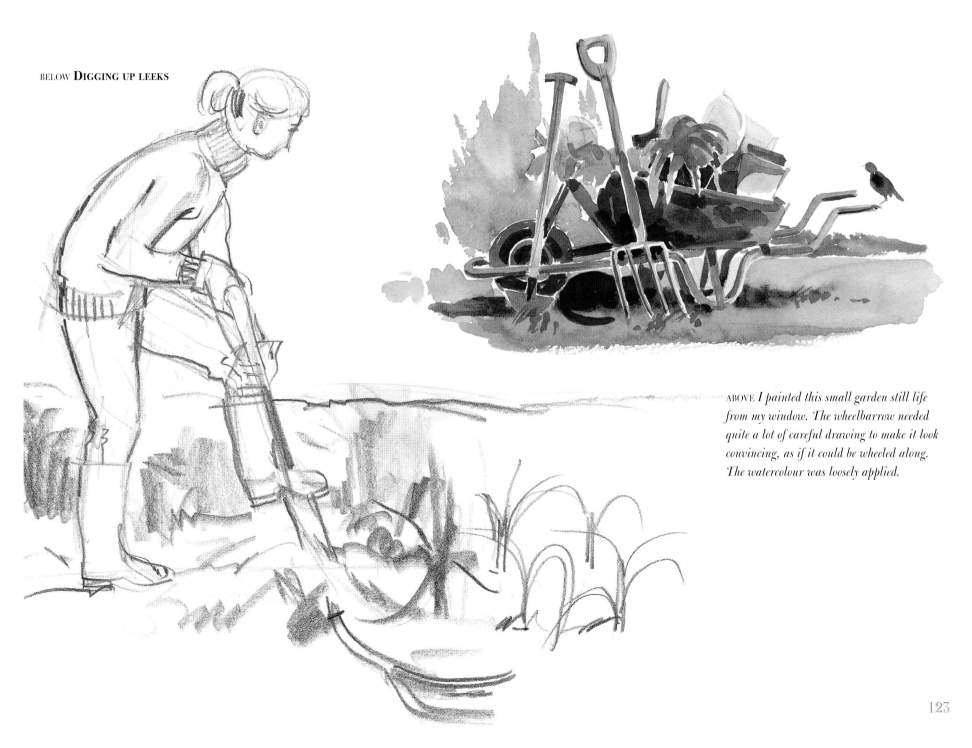

BELOW **DIGGING UP LEEKS**

ABOVE *I painted this small garden still life from my window. The wheelbarrow needed quite a lot of careful drawing to make it look convincing, as if it could be wheeled along. The watercolour was loosely applied.*

123

Winter Flowers

It is amazing how many flowers are in bloom in late winter – snowdrops, periwinkles, hellebores and gorse can be seen at the end of January, and by the end of February jasmine and pulmonaria have made an appearance. The almond tree will nearly be in blossom too.

Indoors, especially at this time of year, I like to have plenty of flowering pot plants, especially the sweet-scented hyacinth. They are so cheering, especially when placed at the window with the winter landscape beyond. I always try to remember to plant the hyacinths in the autumn, and to keep my cyclamen from year to year.

LEFT *This pencil study helped me to make a further study in colour. If you find something difficult to do, try concentrating on a drawing to work out how and why the subject appears as it does.*

ABOVE *This hellebore* (Helleborus foetidus) *is a useful plant for late winter and is a study in green, as both leaves and flowers are this colour. I made a pencil study first as the flowers are quite difficult to draw.*

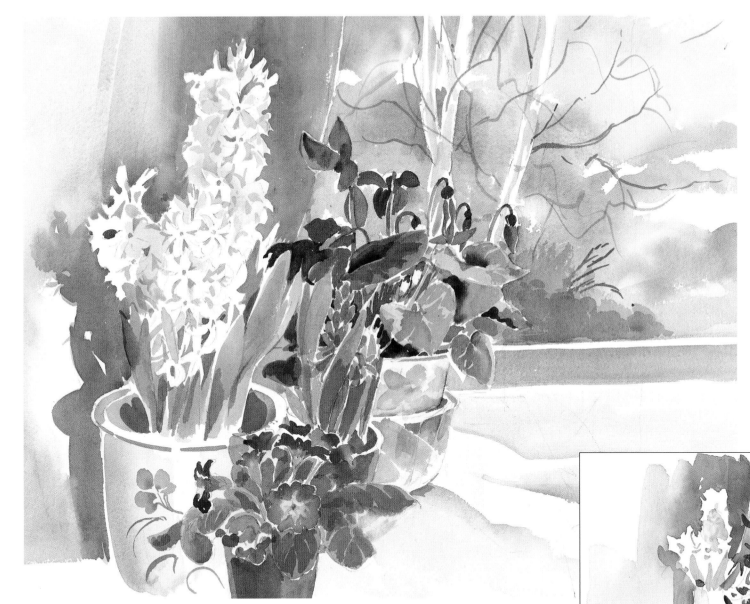

Pot Plants

I grouped these pots of hyacinths, cyclamen and primula (left) by my window. The white hyacinth is held in the composition by the dark curtain, while the stronger cyclamen is against the lighter window. I am constantly thinking of a 'chequerboard' arrangement – of dark to light, and light to dark, with half-tones between. If you are uncertain of this, make a painting in greys working from the very darkest to the very lightest, then it will not be so difficult to translate this into colour as you have already decided on tones. I find small studies very helpful in establishing the composition as well as colour values.

RIGHT *A small watercolour sketch of the pot plants above.*

125

Acknowledgements

Thanks are due to the family and friends who give me so much encouragement,
as well as letting me paint in their gardens and providing me with interesting subjects.
Thanks also to Eileen Hiner for her typing, and for the help I received from
Anna Watson, Freya Dangerfield, Diana Dummet and Susanne Haines.

Index